THE STEP BY STEP ART OF

Paint Techniques

Text and Designs by
DAVID JAPP
Photography by
NELSON HARGREAVES

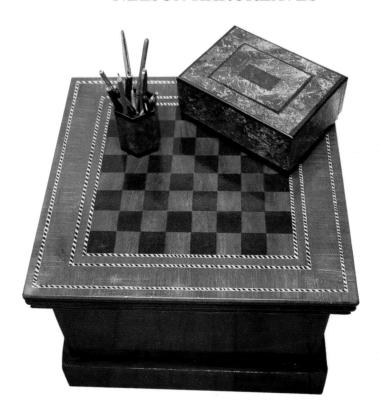

WHITECAP BOOKS

This edition published in 1996 by Whitecap Books Ltd 351 Lynn Avenue, North Vancouver, B. C., Canada V7J 2C4 CLB 4090 © 1995 CLB Publishing Ltd, Godalming, Surrey, England

Printed and bound in Singapore

All rights reserved. No part of this publication may be reproduced, stored in a retrieval system, or transmitted in any form or by any means, electronic, mechanical, photocopying, recording or otherwise without the written permission of the publisher and copyright holder

ISBN 1-55110-225-0

DEDICATION

For Kirsty and Sophie

Managing Editor: Jo Finnis

Editor: Sue Wilkinson

Design: Stonecastle Graphics

Photography: Nelson Hargreaves

Typesetting: Elaine Morris

Production: Ruth Arthur; Sally Connolly; Neil Randles; Karen Staff; Jonathan Tickner

Production Director: Gerald Hughes

THE STEP BY STEP ART OF

Paint Techniques

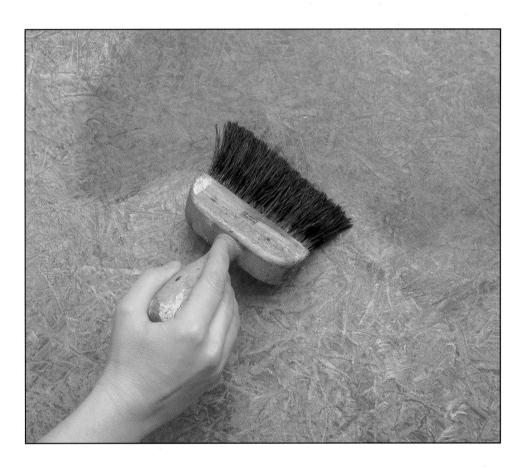

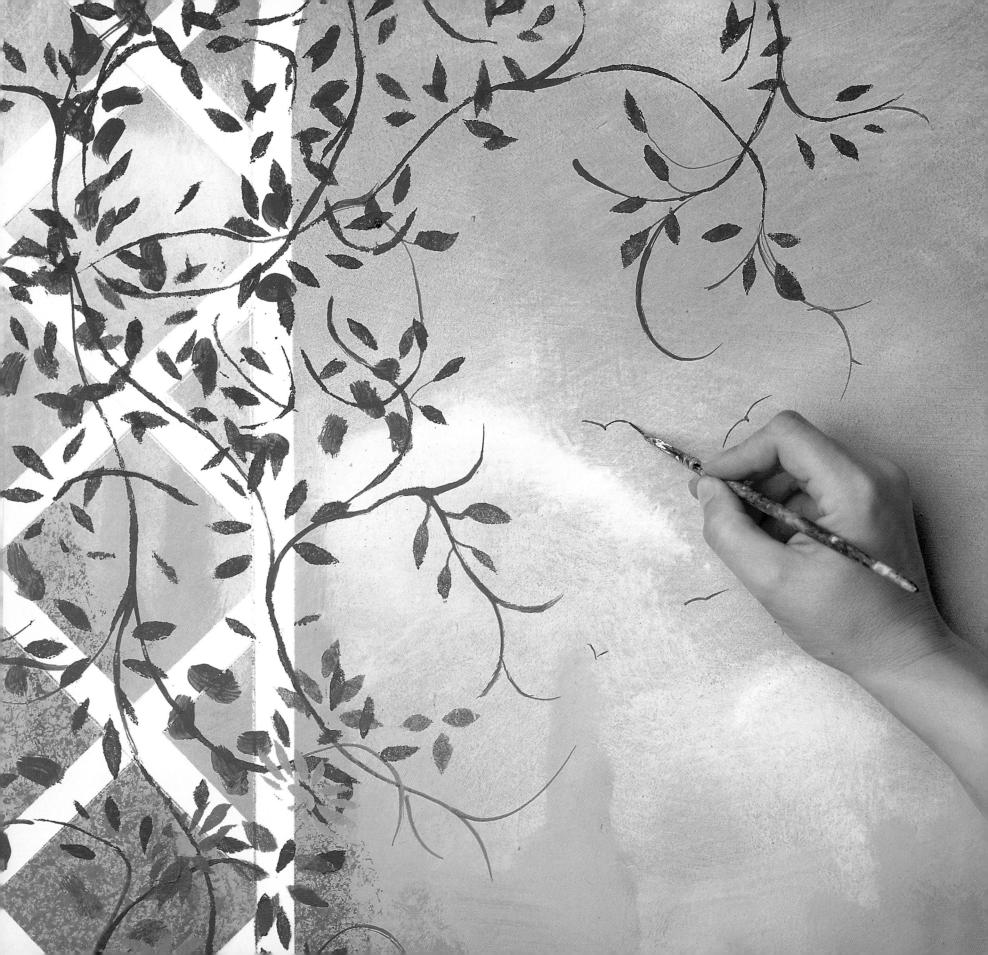

Contents

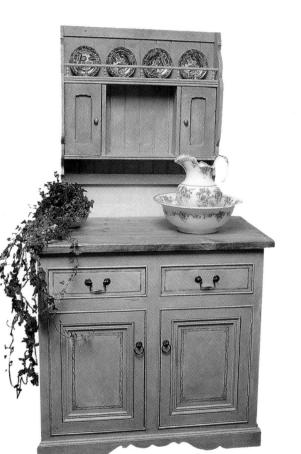

Introduction pages 10-11

 ${\it Materials}_{\it pages~12-13}$

General Preparation Notes
pages 14-15

Paints and Glazes

Colour pages 18-21

Techniques
pages 22-53

Projects
pages 54-101

Templates

Acknowledgements

INTRODUCTION

Playing with different paint techniques can be great fun. All it takes is a little confidence and suddenly the possibilities are endless – a marbled fireplace or a slate floor all created with paint can soon become a reality. The aim of this book is to give you that confidence.

Firstly to help achieve that confidence the book looks at the equipment you need to get started, which includes brushes, paints and glazes. Next you need to understand a little about the use of colour.

Each type of paint finish is looked at in-depth and every stage required to create the look is considered. This makes it as easy as possible for you to start painting the design you want.

For each type of finish the surface preparation, suitable surfaces and the type of equipment needed are described so you know exactly what you will require. This is all backed up with step-by-step photographs which show the important stages of each technique in detail.

Once you are happy with the effects you have created, the best ways to protect the surface are considered. This means that the final finish will be as hard-wearing and durable as possible – which means your work will last.

One of the most important factors to remember when using paint effects is that most mistakes can be rectified fairly easily, so never be afraid to experiment. Paint effects are also perfect for those who like to change their colour schemes or decorative styles, because you can continue to add to and adapt them. Even when a room is finished, if the effect is not quite as you intended, or if you have lived with it for a few years and want a change, then it can be easily altered by painting another glaze or tinted varnish over the original surface.

Before you start painting you need to decide on the type of effect you want to create, the colour schemes you like, and the overall impression you want to achieve. Inspiration for this can come from absolutely anywhere. Old pattern books and reference books from the library might trigger an idea for an individual scheme; a piece of fabric or even a texture found on a piece of wood, bark or a stone.

Even small items can spark off a design - a piece of china with an unusual motif, a picture, or even a bookmark. Sometimes interior paint effects have been created from even more unusual sources, such as a favourite plant in an old terracotta pot, which can inspire interesting and successful colour combinations.

A good general rule when you are looking at your source of inspiration is to use the background colour for your largest surface area. So for walls, for example, paint or glaze the walls in the background colour, and then use the detail colours for the stencil or design. This principle is seen on pages 92–93, where the design for the walls has been inspired by the curtain fabric.

Remember, when taking designs from curtains for walls not to overdo the effect; most paint finishes work best when used selectively, or when they are combined with other surface treatments, fabrics and simple flat colour bases.

Paint finishes and the use of paint techniques go back centuries, during which time they have been subject to the whims of fashion. They also offer one of the cheapest ways of transforming an ordinary room or piece of furniture into something different and special. This fact alone makes them well worth a little investigation.

Paint finishes are seen in the world's most prestigious houses, hotels and commercial properties. Why not look out for different and unusual paint techniques when you are visiting stately homes or commercial properties?

Although it is tempting to follow each recipe or technique in the book, step-by-step, try and develop your own style and personality by experimenting. In addition, when you are trying to re-create the look of wood or marble use a photograph or even a piece of the real thing as inspiration.

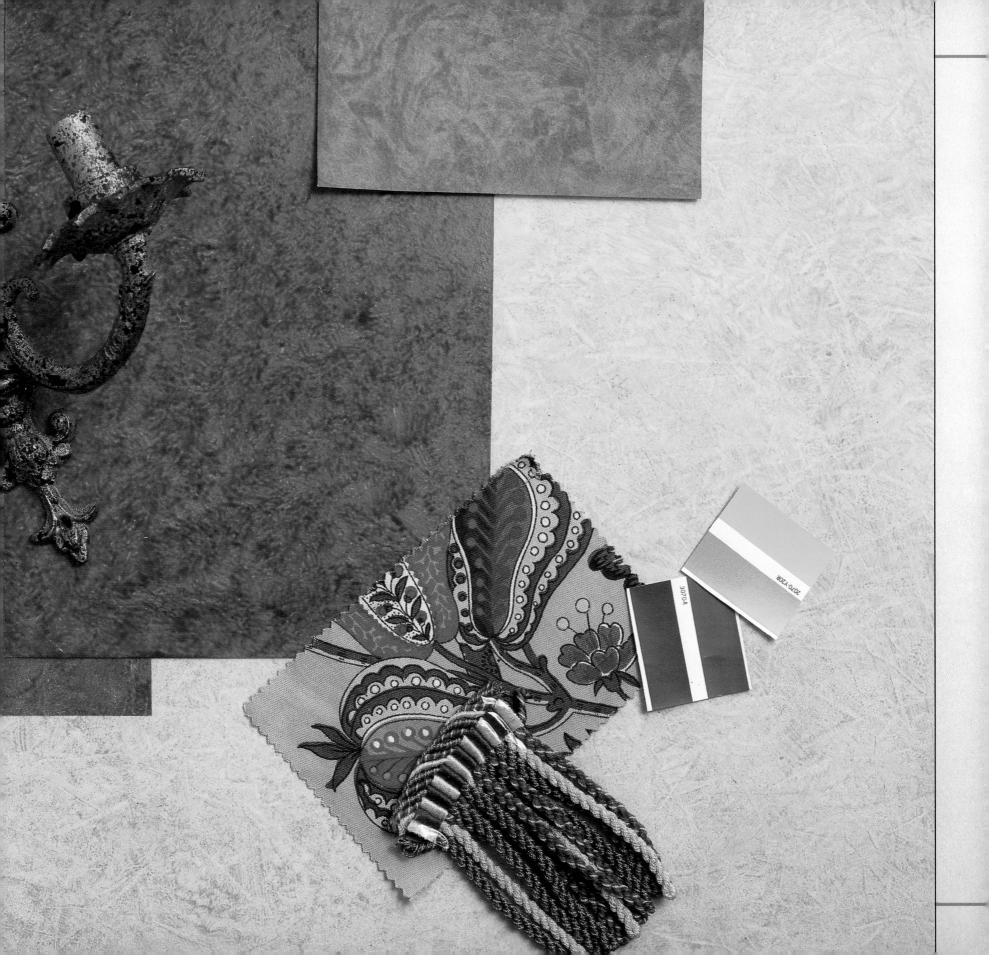

MATERIALS

A lthough specialist brushes are wonderful to own and use, they are not always necessary. Most of the paint effects created in this book can easily be achieved with ordinary, and even old and worn out paintbrushes, paint, glazes and other bits and pieces that you will find around the home.

A cheap dusting brush or wallpaper brush is worth buying as it can be very versatile for a whole host of finishes: dragging, stippling, flogging, distressing, graining, colour washing and even softening marbling marks.

Torn pieces of cardboard, toothbrushes, old shaving brushes, pieces of newspaper, soft rags and feathers can all be used creatively while painting, and an imaginative use of these everyday objects can quickly transform an old piece of furniture, giving it a new lease of life.

A wise investment is a natural sea sponge. Apart from making perfect marks when you are sponging, this can be used when creating a marble effect, and for softening the effect of other finishes. There is no real substitute for a natural sponge; the effect it creates would be difficult to achieve in any other way.

Another good buy is a 'rocker' or heartgrainer, which is used when creating a painted wood effect. You can use the rocker to make the open heartgrain effect which you find in oak or pine. These marks would take ages to create with other tools as the heartgrainer simply creates a series of close, fine lines. The heartgrainer is also useful when you want to achieve a moiré effect, which again would be very difficult to produce with any of the other tools.

A fairly low-tack masking tape is another must when creating some painted finishes. Not only is it useful for the simple task of masking off areas which do not need painting, it is also useful for marking up areas which should have straight lines, and for sticking down pieces of fabric or swatches next to the paint area when you are checking your mixed paint colours. You can see a good example of how useful masking tape can be when it is used to create the trellis effect seen on the mural on pages 58-61.

When painting you will also need somewhere to mix colours. Any tray with a lip will do the job, but you'll find that the best item for this is a paint roller tray, which is fairly inexpensive.

A supply of small glass jars is useful to hold water, white spirit or even a range of mixed up coloured glazes. Small glass jars are also handy for holding small quantities of water-based paint while you are working rather than trying to deal with larger cans.

Old sheets torn into small rags or newspaper will be needed when you are ragging or dragging. Newspaper is also essential for covering up areas like carpets and floors to avoid splashes and spills. If you do need an instant clean-up, liquid detergent is worth having on hand. It can also be added to water-based glazes, to make them more useable.

Another essential is a roll of tissue paper. This is not only used when ragging, it is also perfect for softening some effects, and for instant clean-ups on the painted surfaces. Tissue will quickly and easily remove any paint runs or smudges which often occur by mistake. Tissue is also handy for drying brushes.

For drawing straight lines you will need a ruler or an old piece of dado rail. String is essential if you want to draw circles and is also needed for making makeshift plumb lines with a weight. To draw a circle simply tie a pencil to a length of string then hold the string down where you want the centre of the circle to be. Now using the taut piece of string as the radius draw the circle. For the small inner circle shorten the length of string.

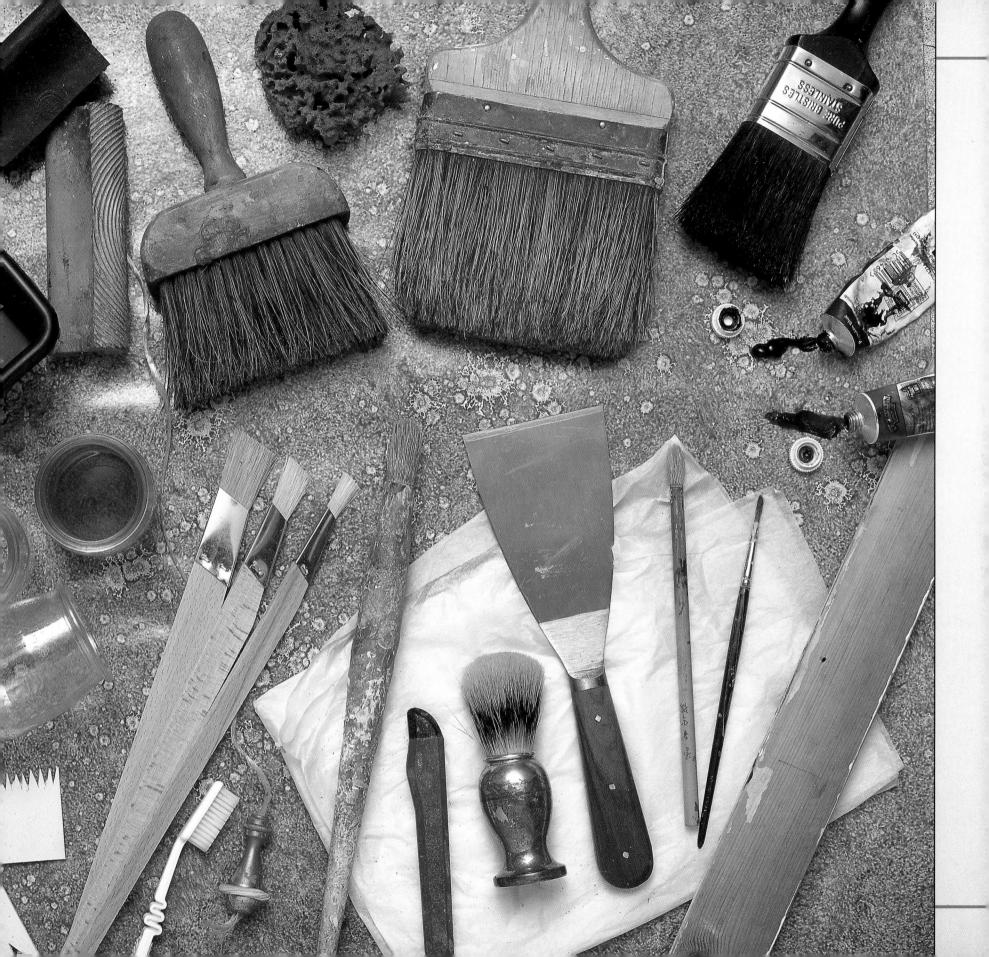

GENERAL PREPARATION NOTES

These general notes on preparation apply to all surfaces unless a specific surface is required.

or oil-based finishes, which are the majority of the finishes found in this book, whether on walls, furniture or objects, the base to which you apply the glaze has to be completely non-absorbent.

To achieve this you first need to create a smooth flat surface. Fill any surface holes or dents then rub down, sand and wipe off any excess dust. Then, if necessary, repeat this process until all the dents are smoothed over before painting. Clean and wipe down, then vacuum the area to eliminate as much dust as possible.

Very porous surfaces, such as lined or plaster walls, must then be sealed with either PVA medium (polyvinyl acetate medium), unibond or emulsion thinned half and half with water. If you are working on new wood give it a coat of proprietary oil or acrylic-based primer. Leave to dry completely.

Metal objects should be smoothed off with a wire brush or emery paper, and then cleaned with white spirit and rags. They will need a coat of metal primer at this stage.

Once the surface has been smoothed down and cleaned off, apply a coat of oil-based undercoat or eggshell, never gloss, thinned slightly with white spirit. Leave this to dry overnight.

When the surface is dry, smooth down again with a piece of fine grade 'flour' paper. This will remove all the small hairs and pieces of grit which may have settled on the surface while it dryed.

Finally, apply another coat of undercoat or eggshell, and again leave the surface to dry overnight.

If you are working with a previously painted or varnished object which is in a reasonable condition, it can be simply 'keyed' by sanding with a medium or fine sandpaper, which basically provides a 'key' for the new paint to adhere to.

If working on a previously waxed surface the wax needs to be removed before the painting can start. Do this by rubbing the surface with wire wool and white spirit, repeating the process until all the wax is removed. Then, lightly sand the surface with sandpaper.

As with everything there are some exceptions to these rules. Sponging can be done on almost any surface straight away, providing that the surface is stable, ie, no peeling paper or cracking plaster. It is even one of the few finishes which can be applied to wood chip.

When a colour wash is applied to a flat emulsion, as opposed to a silky or slightly shiny emulsion, it will sink in like blotting paper, and look patchy. However, if you build up the surface, layer by layer, you can achieve a very pleasing overall effect.

Another good idea at preparation stage is to prepare two or three boards or cards in the same way as the wall or object. These can then be used to try out the paints, glazes and colours and generally practice on before working on the object itself. Making these boards will not take long to do, but will help with building up confidence, and will also be useful at various stages of the finish.

Lastly, you will find that some finishes need more preparation than others, but you should not be put off attempting them because of this. A little practice at the early stages will pay off in the long run, especially if you want the finish to be durable.

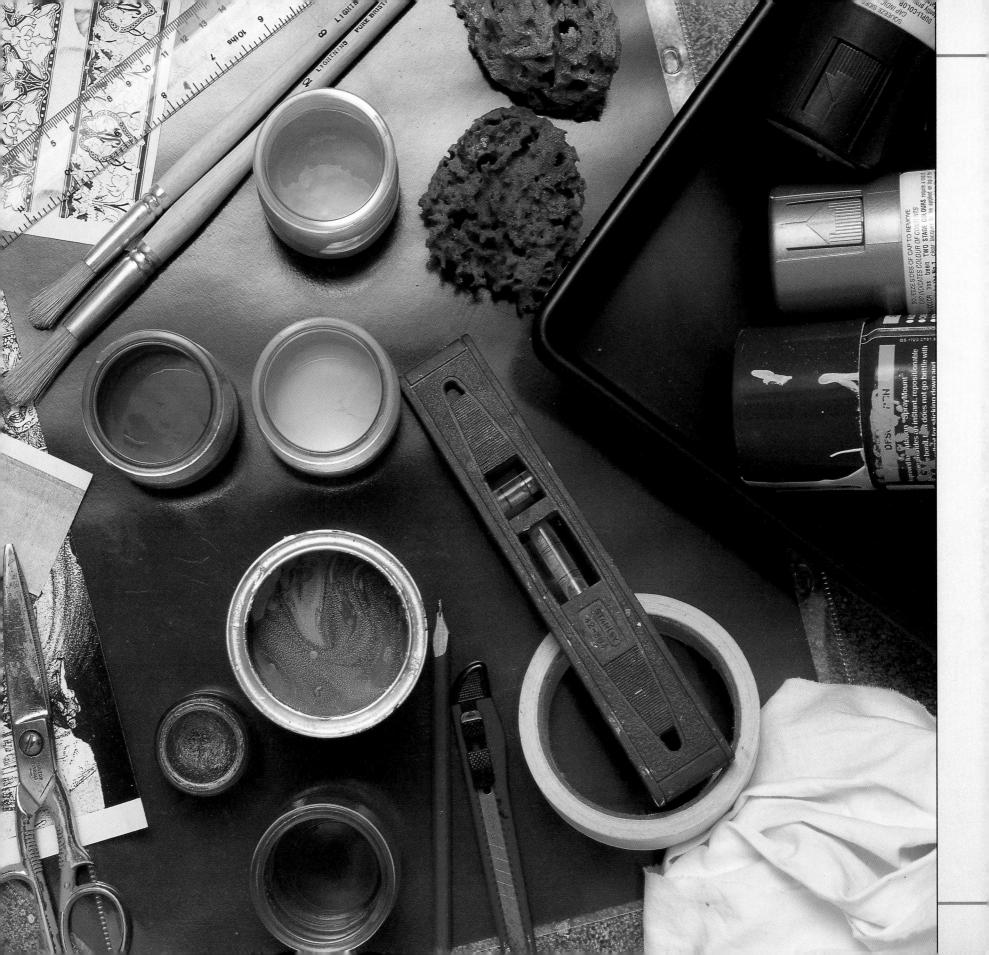

PAINTS AND GLAZES

nce you have decided on the finish you want, you need to decide on the medium you are going to work in: water or oil.

Several finishes including many of the popular ones such as sponging, colour washing, graining and distressing can be created in either medium, so it is up to the individual which one is used.

Most finishes, however, are executed in oils. As a medium, oil is much easier to manipulate, which makes it more suitable for paint finishes. Oils also have a longer drying time and are generally more hard-wearing once dry than water-based paints. They are ideal for furniture, fitted bedrooms, kitchens and bathrooms.

Water-based finishes are by contrast generally less hard-wearing, unless they are well-varnished. They also tend to dry quickly, so are not particularly easy to handle or manipulate. There is one advantage to this, however, if you want to build up layers quickly, especially when sponging or colour washing. The speed of drying means an average sized room can be finished in a day even if you decide to build up four or five different layers of colour.

Other finishes like verdigris use a mixed medium. Many finishes also include the use of cellulose-based sprays.

Whatever medium you choose, you will soon discover that a glaze is much more versatile than paint, in that once it has been applied to a surface it can be manipulated easily and the marks and effects can be more easily achieved. Glazes can also be built up in layers, achieving a depth and movement which cannot be maintained by using proprietary paints straight from a tin.

Proprietary scumble glaze is the main ingredient of most glazes, and can be bought from good decorating stores. This almost transparent medium extends the drying times, and also retains the marks that you make. It is essential when working on a large area using a glaze to keep a wet edge going so you avoid having any bad breaks which will show as lines, patches or dry areas.

It is not a good idea to use a scumble glaze straight from the tin, as it would take too long to dry. A good formula for a standard glaze would be a mixture of 50 per cent scumble and 50 per cent white spirit. The colour is then added either from a tube of artists' oil paint or from an oil-based eggshell. As a rule when mixing a glaze the more scumble glaze you add the longer you will have to manipulate it, and the longer it takes to dry. The more white spirit you add the thinner the glaze.

When it comes to colour itself eggshell paint gives you a thicker mix, whereas adding artists' oils gives the advantage of pure colour without losing the clear consistency of the glaze.

It is best to start experimenting with a 50:50 ratio of scumble glaze to white spirit, and play with this glaze to find out what works for you. The results will vary depending on the item you are decorating, so make up each glaze as you need it. The type of colour you add also depends on preference, and on the object you are painting. Add a little colour at a time, testing it on a board until you are satisfied. If you decide to use artists' oils, mix the colour into a small amount of glaze or white spirit first before adding it to the main glaze. This will avoid the problem of lumps of pure colour. Remember too that oil-based glazes may darken in areas deprived of light.

When you are using water-based finishes, it is generally easier to buy your colour in a proprietary emulsion and thin it with water or a water-based emulsion glaze. If you need to alter the colour, use acrylics or their equivalent which can be bought from an art shop. Again, mix these colours in a little glaze before adding to the main glaze.

Be particularly careful when handling toxic or hazardous materials. Always follow the manufacturer's instructions and ensure that the area you are working in is well-ventilated. Use plastic gloves and masks when possible.

Always lay rags charged with scumble glaze out flat to dry before disposing of them as they are liable to combust when wet.

Colour

olour is probably the most predominant feature of any paint effect, and yet colour mixing is a difficult thing to try to teach. It is really something only learnt by trial, error and patience, although there are some basic principles which can act as a sound starting point.

When you are mixing colours it is important to remember that colour is a personal thing. Different people react to colours in a variety of ways, and you must bear this in mind so that you consciously choose colours which create the right atmosphere for you. Consider colours in relation to their surroundings and never in isolation.

When decorating a room think of the overall atmosphere you want to achieve. Do you want to create a light room or a warm and intimate room? Is it a cold room needing to be made cosier? Do you want to make a small room appear larger, or a large room less daunting? Do you want to lower a ceiling or make a feature of an alcove? The colours you choose and their tonal values will go a long way to addressing some of these problems.

Remember, too, that colours change dramatically in different lights: daylight, electric light, spotlights or subtle downlighters. So you will need to think about the style of your lighting in the overall plan. Finally though, it is about personal instincts and personal preferences, and a little common sense is useful at this stage.

The principles of colour can get a little complicated, but again if you apply that same common sense you can avoid problems. There's no need to get bogged down or frightened off by so called 'rules' about primary, complementary, tertiary or discordant colours. If you are interested in finding out about the principles fine, but don't let the rules scare you, or make the subject seem too complicated.

When you start to think about colours, remember the designs and patterns that inspire you and try to use those colours. It will give you more confidence when you think that these colours were originally created by a designer. Use

the background colour on the design for your largest painted area, then introduce lighter and darker tones of the same colour, or pick other colours from the object to create interest, depth and more detail.

If you mix your own colours and glazes rather than using proprietary mixes, you will need a basic palette of colours either in artists' oil colours, oil-based glazes and finishes, or good quality acrylics for finishing water-based glazes.

A basic palette of red, blue and yellow, (cadmium red, French ultramarine and cadmium yellow, for example) would provide your three primary and main sources of colour. Assuming you do not want to use the colours pure, you need to transform them into viable decorating colours. A good range of earth colours would be burnt umber, burnt sienna, raw umber, raw sienna and yellow ochre. Black can be useful, and you'll need white. The earth colours are excellent for improving the quality of colour, and will work better than black if you want to darken or add depth to a colour. Black makes colours look duller.

Once you have pulled together your basic palette, you will be able to mix most of the colours you will need.

Some finishes require particular colours, lapis lazuli, for example, will need Prussian blue, which cannot be made from this basic palette. Deep red or a particular green are difficult to mix, so in these cases buy the actual colour.

Another alternative is to use universal stainers with a colour. The main advantage with these is that they mix both with water- and oil-based materials, but they do not give such a feeling of quality as the artists' oils. When using proprietary materials, it is important to follow the manufacturer's instructions as these may vary between brands.

Gain confidence by experimenting with colours first. Squeeze a little of each colour on to a white board, then add a tiny amount of one of the "earth" colours, or a little white.

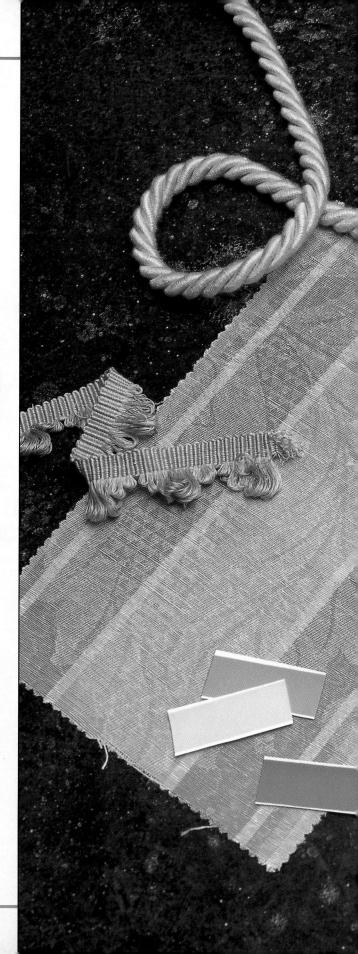

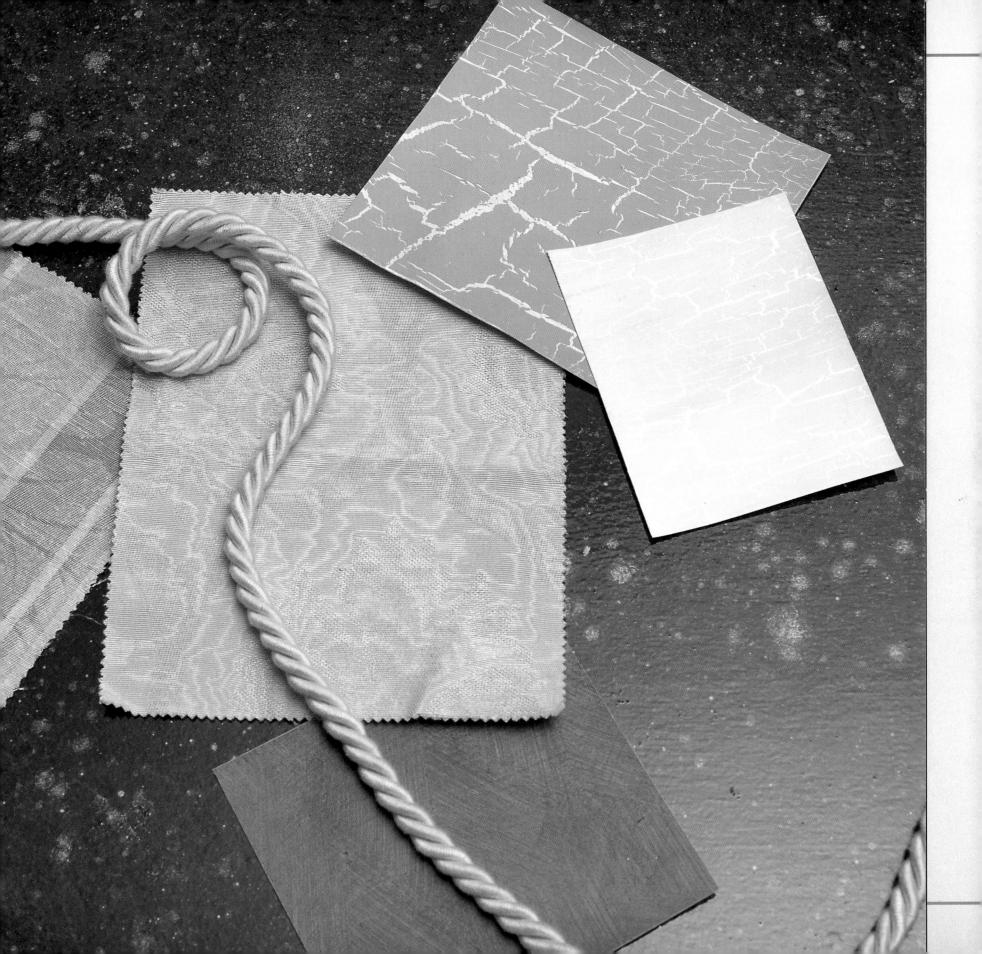

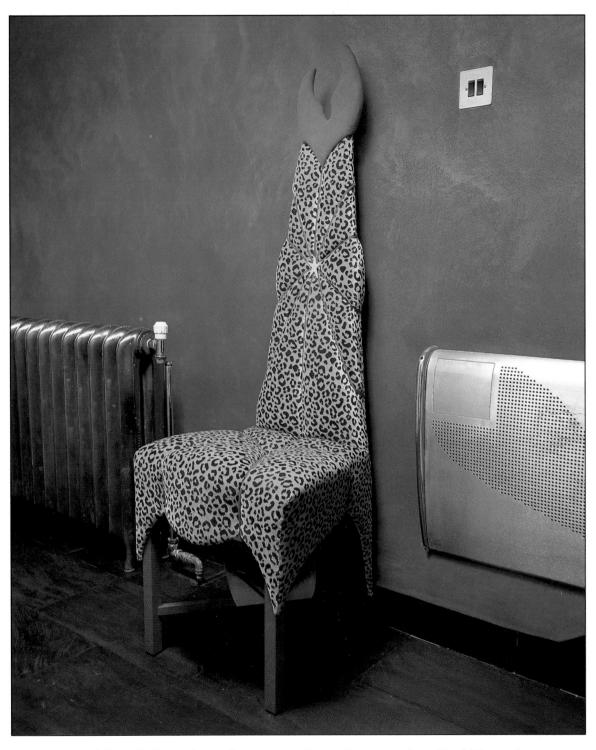

ABOVE: A painted plaster finish provides a perfect backdrop for this designer chair. Any other setting would detract from the chair's elegance.

RIGHT: By mixing and matching fabric swatches, papers, paints and textures you can decide on the room scheme before you start to paint.

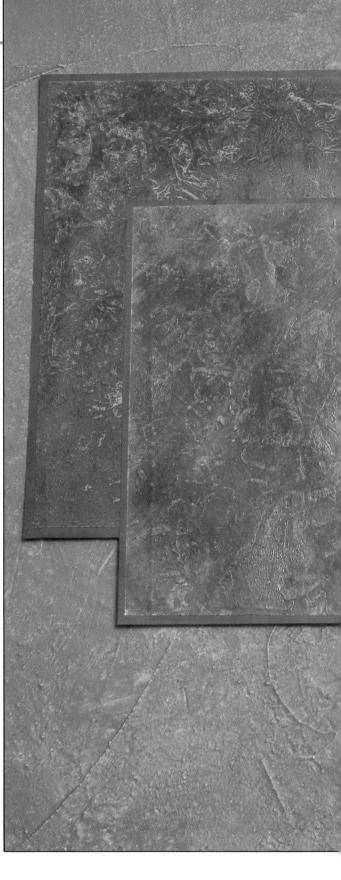

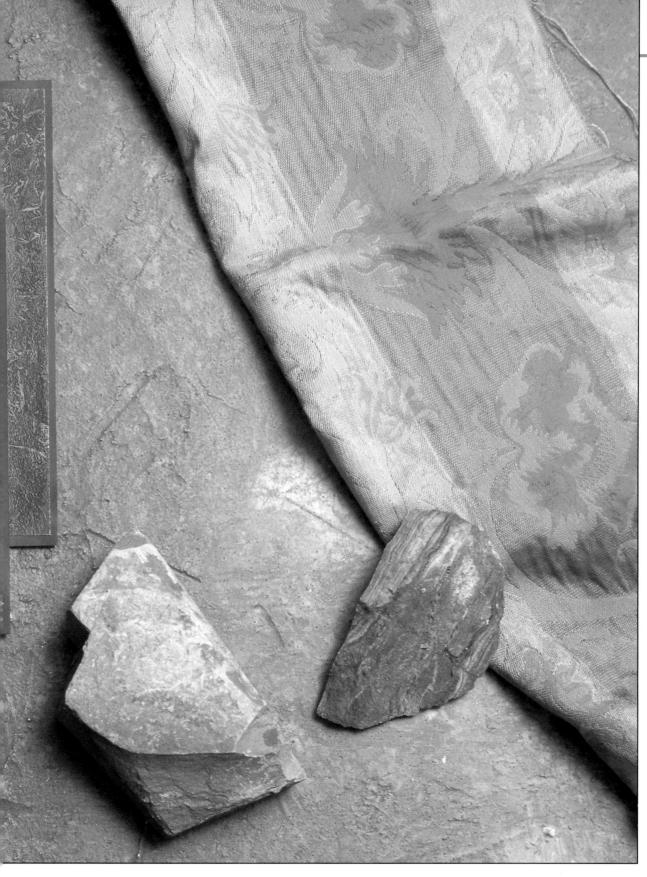

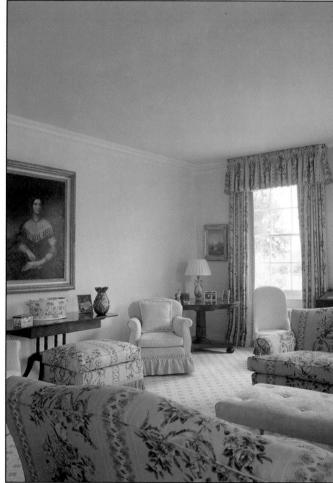

ABOVE: Before the work started paint colours, fabrics and accessories were chosen. The result is a strikingly elegant and relaxing room, which works without looking stale.

TECHNIQUES

Almost every paint technique you are ever likely to want to create is included here, from realistic lapis lazuli and malachite, to the more simple, but very effective sponging and ragging effects.

Every stage of each process is clearly explained and illustrated with the aid of step-by-step photographs.

Wherever necessary diagrams have been included to make the specific techniques even more accessible.

Once you are happy with your final effect the best way to protect your surface is also considered.

RAGGING AND STIPPLING

hese finishes are similar in technique, in that a glaze is applied and then manipulated with either a brush, rag or newspaper.

Both finishes should be applied to a well-prepared surface. A surface painted with two coats of eggshell is ideal. You could use a water-based glaze, but for a more professional finish try an oil-based mixture of at least 50 per cent scumble.

Stippling is a sophisticated finish and is best done in one layer, while ragging can be built up in layers. Working with layers, leave the first layer to dry completely before applying the next. Experiment with rags, newspapers and polythene before you decide on your finished effect.

Proper stippling brushes are ideal for stippling, but are expensive. A large light wallpaper or dusting brush achieves a similar effect. Rotate your hand, when off the surface, to avoid creating a pattern.

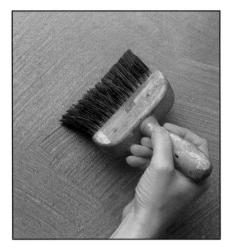

1 Apply the glaze evenly using a soft brush. Work the glaze drawing a basket weave effect using light brush strokes to achieve an even coverage.

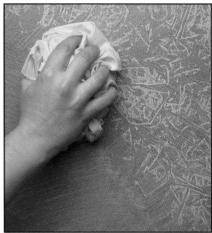

2 Crumple a rag or cloth so that it is easy to grip. Dab the glaze with the rag, turning your hand as you work. This will avoid a regular pattern being created.

ABOVE: Working a wet edge is important for both finishes. On large areas one person could apply the glaze while the other rags.

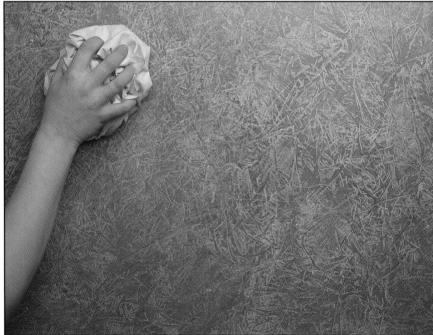

3 To create a softer look, rag off more of the glaze with a soft dry rag, using the same technique as before. Stand back occasionally to check you are happy with the effect. Change the rag as necessary.

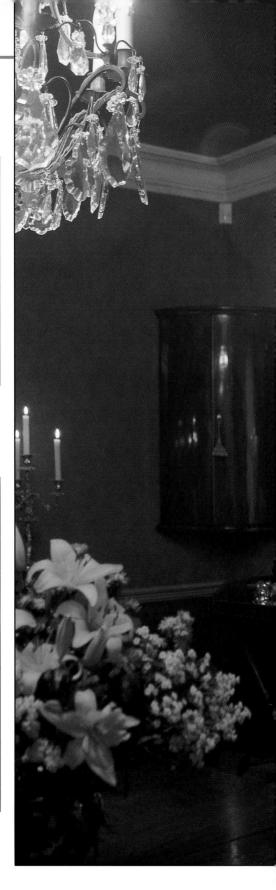

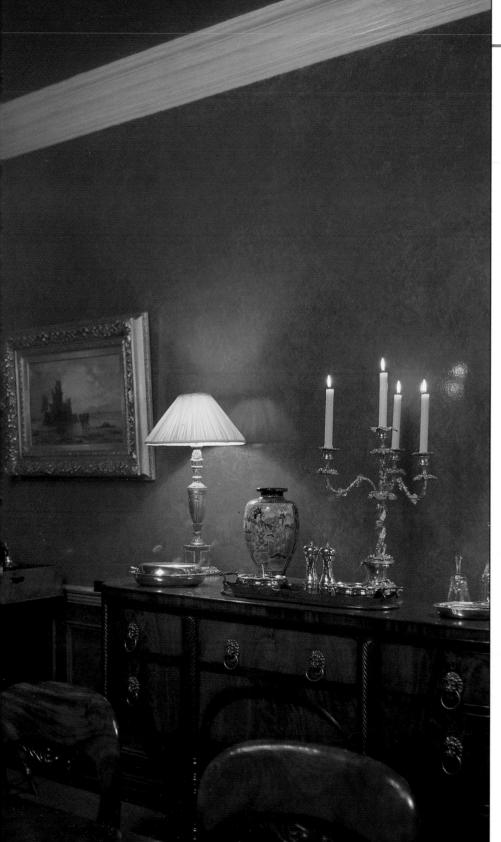

4 This is another way of creating a ragged effect. The wall has been stippled beforehand to eliminate any brush marks, which show with ordinary ragging.

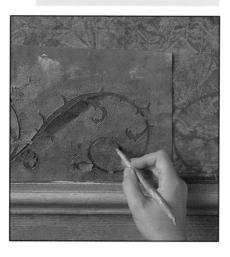

5 A ragged background is ideal for a stencilled frieze or border. In this case, a stippled gold stencil is painted on a deep red, ragged background.

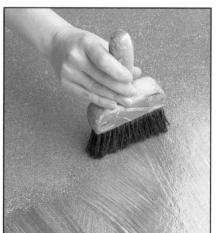

I When stippling, apply the glaze evenly, then use a dry, stippling brush or wallpaper brush, to stipple the area. If you are putting glaze back on to the surface the brush is too wet.

LEFT: A mid tone red oil-based eggshell has been ragged with a deep crimson glaze to give a very dramatic effect, which is enhanced by subtle lighting.

2 Stippling is a delicate effect which lends itself to strong colours. Tint the glaze with artists' oils rather than eggshell which thickens the glaze and give the glaze more movement by using 60 per cent scumble to 40 per cent white spirit.

DRAGGING

his paint effect is a straightforward and simplified version of woodgraining, which can be achieved on most reasonably smooth oilbased surfaces. The effect can be created using a variety of different glazes. Although the technique works on walls, it is best on woodwork. You can use any brush, but old brushes sometimes give a more attractive effect. On walls always drag the brush from the top, to about halfway down, then drag up, easing the pressure and lifting the brush off the wall as it passes the area already dragged. Vary the height of this break.

Keep the brush as dry as possible as it quickly absorbs glaze. If a flogging effect (a looser combed look) is required hit the panel at random as you work down. Use a standard oil-based mixture of 50 per cent scumble to 50 per cent white spirit.

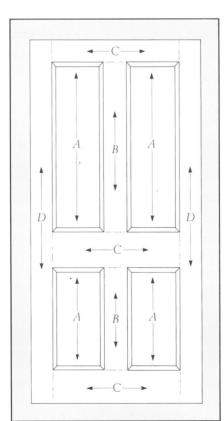

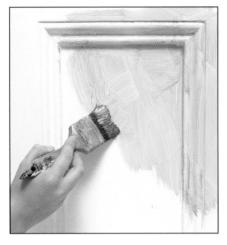

1 Apply the glaze evenly on one panel.

Take a firm brush and drag down from the top of the panel to the bottom. Then, lightly drag up to lift the build of glaze.

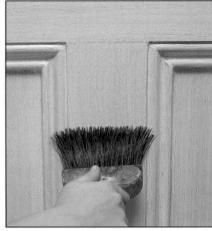

Once the panels and mouldings have been dragged, drag the middle verticals, the horizontals and finally the two side verticals to echo the grain of the door.

LEFT: Drag the middle panels A first, then drag the two vertical panels B, then the three horizontal panels C. Finish by dragging the vertical side panels D.

3 From this detailed shot of a dragged door you can see how the brush directions work.

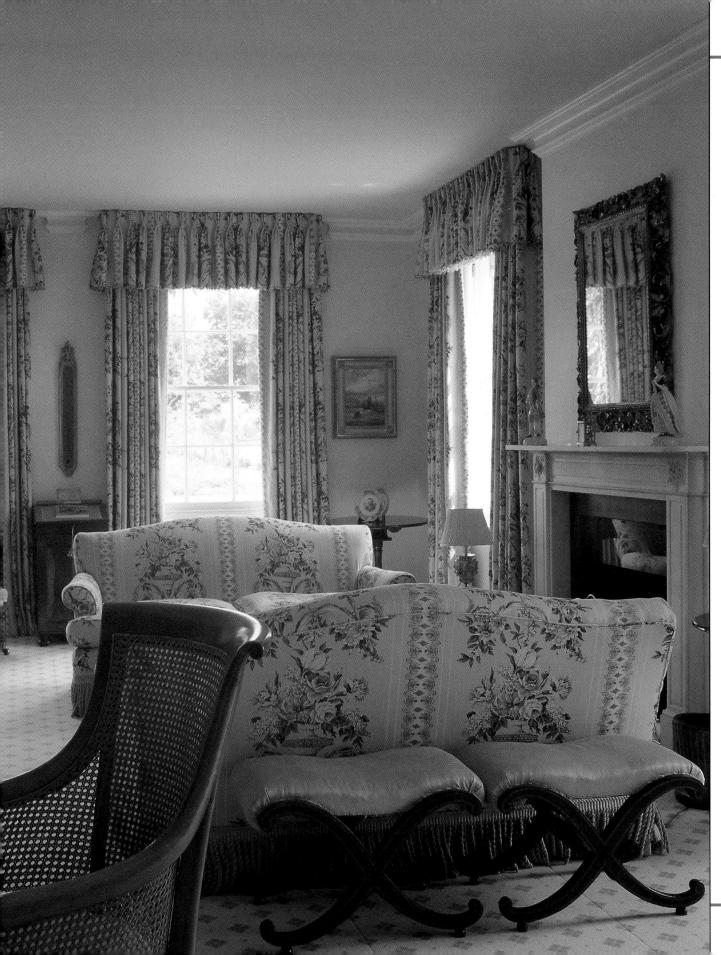

ABOVE: This close-up detail of the living room in the main picture shows how subtle and stylish a dragged effect can be.

ABOVE: The dragging technique has been worked around the panels of this wardrobe, while the main panels have been ragged. The two techniques work well here.

LEFT: Although subtle, the walls in this living room have been dragged using a sunshine yellow glaze. Teamed with dark woods and soft, inviting sofas the room looks very relaxing.

SPONGING

ponging is probably the quickest, easiest and most versatile of all the paint finishes. The finish can be worked on almost any surface, even woodchip, and any mistakes can be rectified fairly easily.

You need a sponge that is large enough to sit comfortably in your hand. It is best to buy a natural sponge for this technique, although you could modify a decorating sponge by tearing pieces from it so that it makes good marks.

If you are sponging walls use a waterbased emulsion, and thin it slightly with water. If you are working on wood use a slightly thinned oil-based eggshell, which will be more durable. You can also use this paint technique on smaller objects.

Pour some of your paint into a tray then dip the damp sponge into the paint. Dab off any excess paint before working.

1 Dab the sponge on to the wall working with a constant pressure, but varying the angle to avoid making clear patterns. Work as close to the corners as possible.

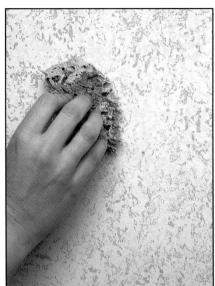

Leave the first colour to dry. Ensure the sponge is clean, then apply a second coat, either a second colour, or another shade of the same colour.

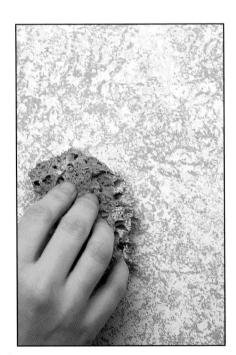

3 Once the second coat has dried, you could add a further colour, or a lighter shade of the original. Remember that the final colour will be dominant.

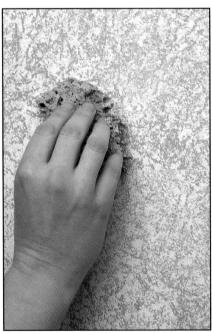

4 Finally the last colour or shade can be sponged over the surface. Again this should not be added until all the other colours have dried.

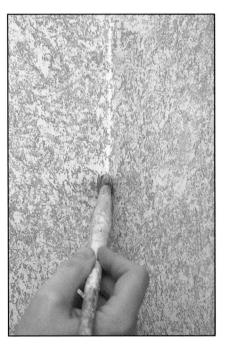

5 For corners and skirtings use a small artists' brush, or a fitch, to fill in the colours. Do this while you are working each colour rather than at the end.

ABOVE: A light sponge effect has been worked on this wall. A natural sponge was used, which had fairly tight gaps, thus giving a soft, speckled effect.

ABOVE: This is a more dramatic sponge effect, created by pushing the sponge down harder on to the wall and using a sponge with much larger holes.

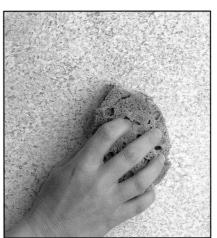

ABOVE: A quick and easy way to tone down a colour is to work a layer of white all over the effect.

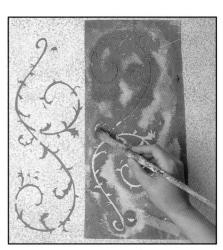

ABOVE: A sponged background is great for stencilling on. Here, an interesting frieze is created with a blue and red stencilled design.

LEFT: This interesting sponged effect was built up in layers using three or four different colours which were taken from the fabric.

COLOUR WASHING

his technique lends itself to a rustic country look, but it is versatile enough to be used in most settings if suitable colours are used. The effect works best when using earthy colours such as Venetian red or raw sienna.

For this technique to be effective, the paint should be built up in layers. This helps to create a look with more depth.

This paint effect can be created using either an oil- or a water-based paint, but it is quicker and easier to work with water-based paints. Mix a small amount of your chosen colours in the paint and then thin the mix down with water to a ratio of 50:50. If this is still too thick simply add more water. Although this technique can be worked on a smooth wall, we have created a slightly rough background surface to enhance the finish.

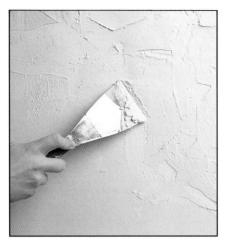

1 To prepare a surface spread a thin layer of fine plaster over the wall. When dry seal with emulsion thinned with water, then paint with two coats of emulsion paint.

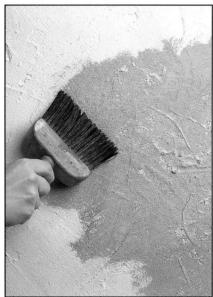

When the base coat has dried use a large brush to paint the prepared mixture on to the surface. Work quickly and evenly.

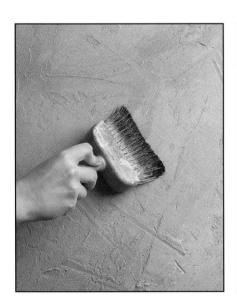

3 For a more distressed look rub the glaze into the surface with a dry brush, clean it on a rag as you work. Repeat if the effect is patchy.

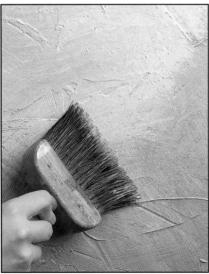

4 To achieve a dusty, aged look to the colour washed effect, paint another layer of off-white, water-based paint thinned with water over the surface.

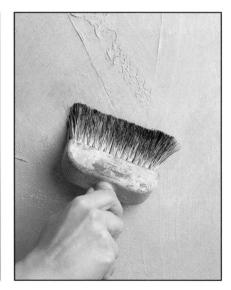

5 Before the off-white paint has dried, rub the paint into the surface using a dry brush. Again, dry the brush on a rag as you work.

Jechniques

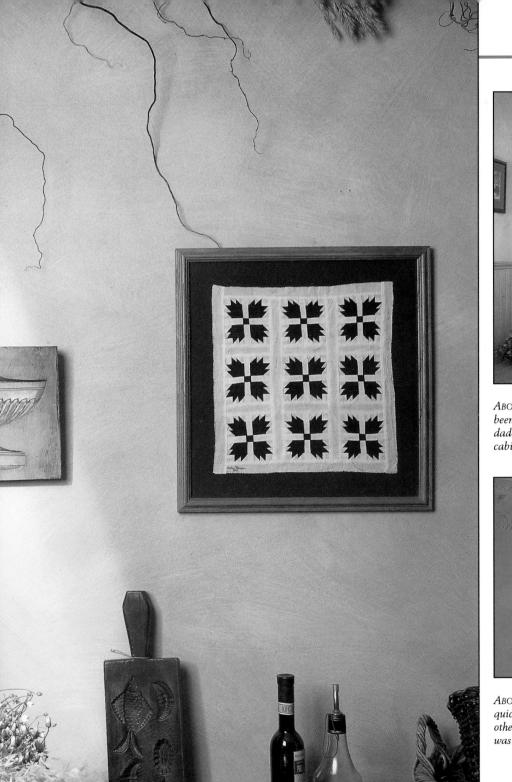

ABOVE: The walls above the dado rail have been treated with a yellow colour wash. The dado has a crackled paint effect, and the cabinet has been stencilled, then aged.

ABOVE: Although often considered as a rustic wall treatment, colour washing can work well anywhere in the home. Here, it is found in a modern living room, giving extra depth to plain walls.

ABOVE: A simple colour wash can be quickly transformed with the addition of other colours. Here, a proprietary stencil was used to enhance the final effect.

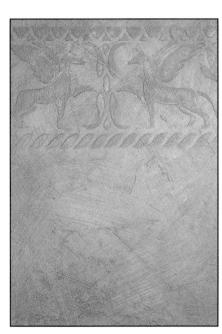

ABOVE: Looking at the stencil more clearly you can see how paint effects such as colour washing and stencilling work so well together, if the colour themes are matched considerately.

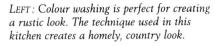

Jechniques

SPATTERING

pattering is a very simple, straightforward paint technique to achieve, but it is also much more than a light-hearted effect. If used thoughtfully, for example, spattering with a variety of grey, black and white paints can add depth to a painted object. And by simply spattering a little brown over the surface the overall effect could even be made to look like granite.

Although this effect can be created on walls, it is very messy to execute so it is better worked on smaller objects like letter racks or lampshades.

Try experimenting with different colour combinations, on a piece of card, before you work on the final item. Remember that the size of the spattering dots depends on how close the brush is to the object and how much paint there is on the brush.

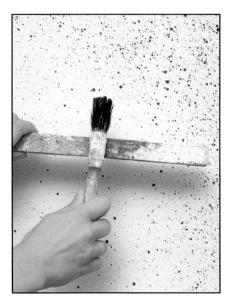

1 Dip your brush in the first colour, in this case black, then hit it against a piece of wood aiming at the area you want to spatter.

2 Wash the brush after the first coat then repeat the process with the second colour, in this case grey.

3 Repeat the process again, using a third colour, in this case white. When spattering there is no need to wait for one colour to dry before proceeding to the next.

4 This is the same process, using black, grey and white paint, but worked over a dark grey, rather than a white background.

5 Spattering can create a range of different effects. The door on the left has been given a metallic paint finish, enhanced using the spattering technique.

RIGHT: Some of the selection of spattered objects here have been enhanced with gold and black stencils or borders.

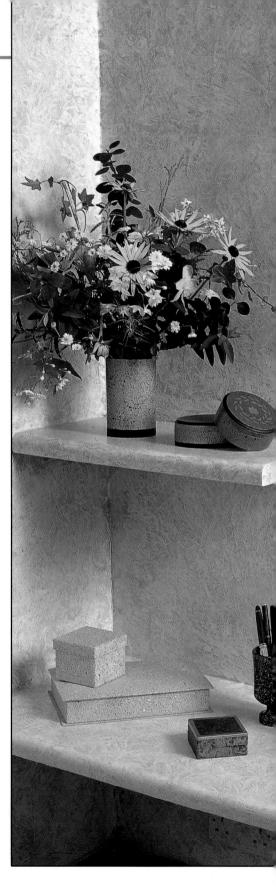

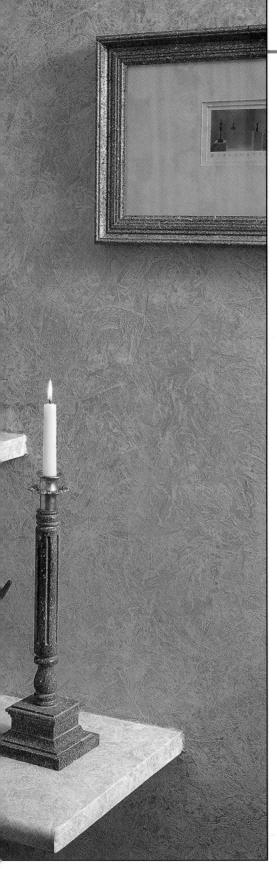

LIMING

istorically wood was limed to protect it, but the technique has grown in popularity as a way of simply enhancing the characteristics of wood. The technique is particularly good for open grain woods such as oak, and also works well on moulded or carved surfaces, where it helps to highlight the carpenter's craft. Providing the object to be limed is stable and solid in structure the technique should work well. First clean the object thoroughly and remove any wax, or previous varnishes. The best way to achieve this is to use wire wool and white spirit.

There are a number of different materials you can use to achieve a limed effect. White emulsion thinned with water, thinned oil-based white undercoat or thinned eggshell are all good. Alternatively you could use a proprietary liming wax. Here we have used 70 per cent oil-based undercoat thinned with white spirit.

1 Use a wire brush to lift the grain.

Always brush in the direction of the grain and never across the grain.

Apply the liming mixture with a paintbrush, working one panel at a time. Work the mixture into the grain and in to any mouldings or cavities.

ABOVE: The main door has been treated with a simple white liming mixture, while the small door has been painted with a coloured liming mixture. Any colour of paint could be used to achieve this effect.

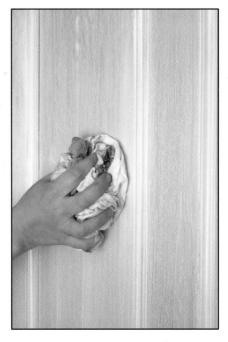

3 Leave the mixture on the object for a few minutes, then wipe off excess paint with a hard cloth, hessian is ideal. Repeat the process if you wipe off too much.

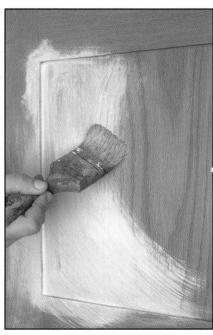

4 This is an example of liming an object in a different colour. A small quantity of green paint was added to the liming mixture to achieve this effect.

TORTOISESHELLING

The inspiration behind the paint technique of tortoiseshelling comes from the Far East. In these countries they used the shell of the sea tortoise as an inlay for small pieces of furniture. As traders travelled these items were introduced to the West. However, by the nineteenth century the turtle was declared an endangered species, and the paint technique became popular.

This technique is particularly successful when it is used on small objects. While painting bear in mind that real tortoiseshell comes in an infinite variety of marks. Almost any combination of raw sienna, burnt sienna, burnt umber, crimson and black can be used. It is best to experiment with different proportions of colour. For example, paint a large area of raw sienna, with small areas of burnt umber and black.

Badger hair brushes were used to soften this effect, but they are expensive and environmentally unfriendly. An alternative is a soft dusting brush, worked delicately.

Before you start, ensure that the working surface is as smooth as possible. Prepare the surface with a coat of golden, yellow oil-based eggshell. Protect the finished effect with at least two coats of high gloss oil-based varnish.

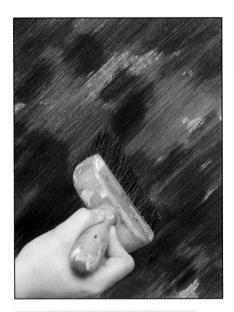

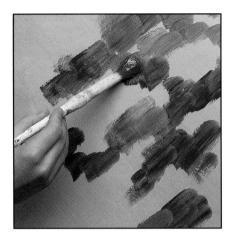

1 Paint a clear glaze (50:50 scumble to white spirit) over the surface. Then, using a small brush and an artists' oilbased raw sienna paint diagonal marks.

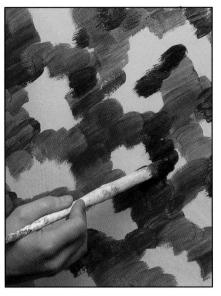

2 Using the same brush, repeat the process with burnt sienna, and covering more of the working area.

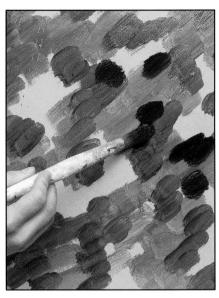

3 Again repeat the process using burnt umber, and filling in even more of the working area.

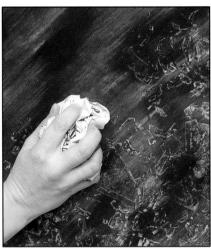

5 As an option dab a piece of crumpled newspaper over the surface, or use a natural sea sponge dipped in white spirit.

4 Using a soft dusting or pasting brush gently blend the colours together. Take care not to blend too much or you will loose the contrasts.

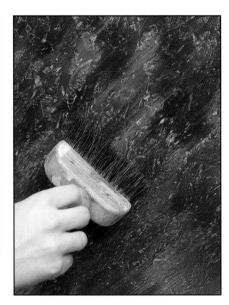

Soften the newspaper effect by again brushing the soft dusting brush or pasting brush over the surface.

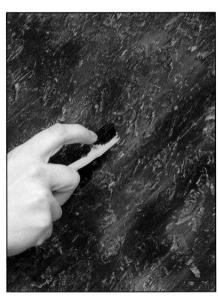

Finish off by dipping the tip of a toothbrush into black oil paint mixed with a little white spirit, and lightly spatter the surface to add interest and depth.

Jechniques

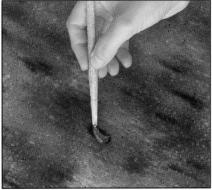

8 Enhance the final effect by painting in small areas of black using a small brush. Work carefully and use a small amount of paint.

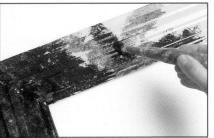

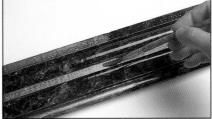

ABOVE: The top photograph shows the first stages when creating the tortoiseshell paint effect on this frame (seen left) using different proportions of colour. And, just above you can see the finishing touches being picked out with gold paint.

LEFT: The tortoiseshell paint effect works best on smaller items. Here, it has been used on the candle holder and around a bathroom mirror. It works so effectively it could almost be the real thing. This effect always looks sumptuous and expensive.

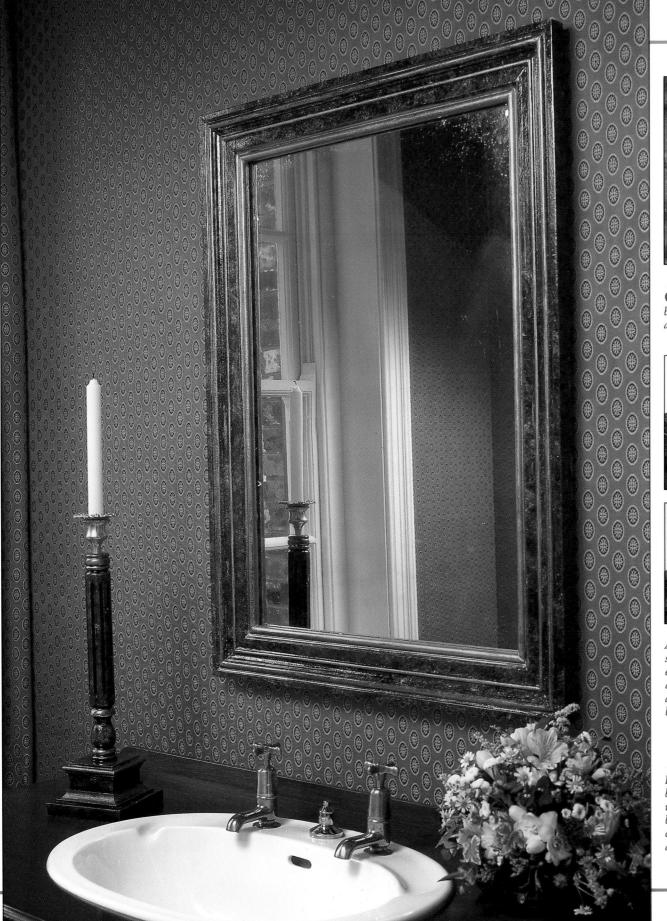

MALACHITE AND LAPIS LAZULI

alachite is a semi-precious mineral which is sometimes used as a source for green pigments, but is often found in its polished state in jewellery. As a finish therefore, it is most effective if used selectively.

Before you begin try to obtain either a piece of malachite or a picture of malachite to work from. Try not to copy this, but aim for a similar design. The basic look is a dark green, highly-polished effect which is often highlighted with gold details.

This paint technique is worked on a mid-emerald green base, which should be painted with an oil-based paint. You will need a 50 per cent scumble to 50 per cent white spirit glaze, and artists' oil colours in viridian, raw umber and Prussian blue.

Lapis lazuli was also used as a source for ultramarine pigment, but because of this use it became quite scarce, and hence became popular in its polished form as a gemstone. Like malachite, the paint technique is best used on small items.

The paint finish should create a milky effect with gold and white flecks floating in a deep ultramarine glaze. Both of these techniques are applied to a smooth surface. Protect the effect with two coats of high gloss oil-based varnish.

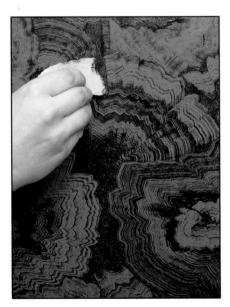

1 Viridian is the predominant colour in malachite. Paint the three colours on to the work surface, stippling and blending to create a predominately green layer.

Lightly score different sized pieces of card, and tear along the score lines. Use these edges to make broken circles in the stipple glaze, varying the size of marks.

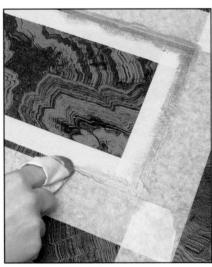

4 The malachite paint effect can easily be enhanced with gold paint. Mask off the area before painting.

Once you are completely happy with the result, leave the paint to dry completely. Then, protect the surface with a couple of coats of gloss varnish.

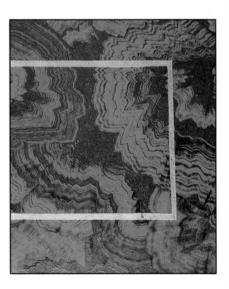

5 Here is the finished box complete with gold details.

RIGHT: Set against a lapis lazuli table, the two green boxes have been treated with a malachite paint finish then finished with gold stencilling on the lids.

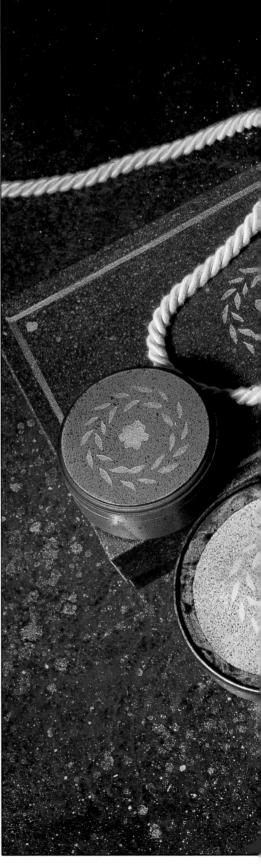

Jechniques

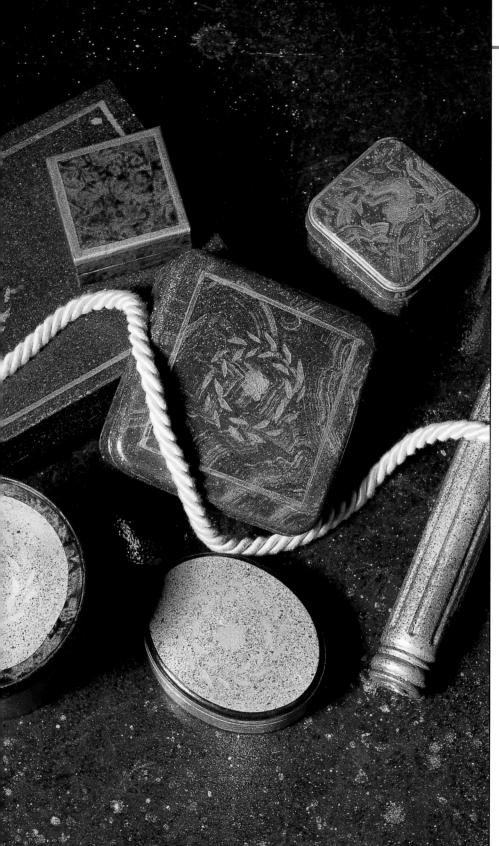

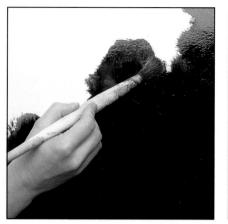

1 Paint a clear glaze on to a white oil basecoat. Stipple artists' oil colours over this. French ultramarine predominates but Prussian blue and raw umber are used.

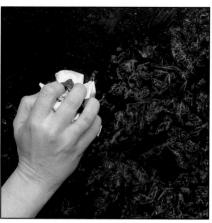

2 As an option add interest by crumpling a rag or newspaper and using this to dab the surface lightly in places.

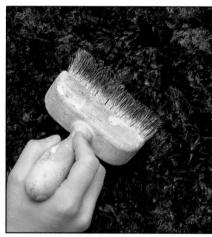

3 Carefully soften the effect using a soft dusting brush.

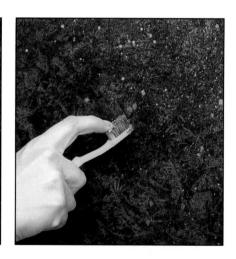

4 Mix a little gold paint with white spirit and use a toothbrush to flick this paint on to the surface. Repeat with white paint.

RIGHT: A detail of the finished lapis lazuli table shows the depth and purity of colour which can be achieved.

AGEING AND DISTRESSING

here are a number of ways to make an object look older than it really is. The most dramatic of these is to throw stones and buckshot at the object – but this may not really have the desired effect. A less drastic method is to start by rubbing off all the hard, sharp edges and corners then paint the object with a dark background colour; a deep red or dark brown is perfect. Then apply a thick coat of wallpaper paste to the object. For more dramatic cracks add a little gum arabic to the paste. Leave the coating to dry completely.

Once the object has dried, coat the whole area with a heavy coat of off-white matt emulsion then dry it with a hairdryer on the hottest setting. If after ten minutes no cracks appear mix a little more gum arabic into the wallpaper paste and repeat the process.

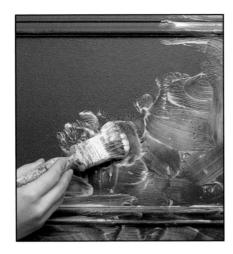

1 Sand the surface. Apply a water-based colour over the whole area. Leave to dry. Then apply a thick coat of wallpaper paste and gum arabic. Leave to dry.

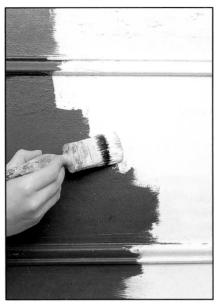

2 Apply a coat of off-white matt emulsion or an alternative water-based paint over the top of the paste.

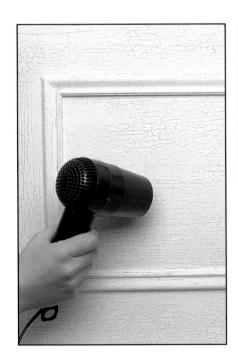

3 Once this coat of paint has been applied dry the whole area with a hairdryer on maximum heat. Cracks should appear fairly quickly.

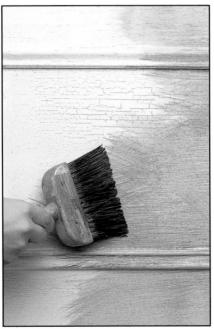

4 Mix a small quantity of raw sienna and raw umber acrylic paint with a little water and paint over the surface, rubbing it into the cracks.

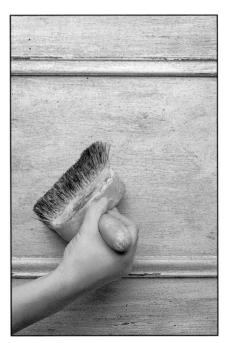

5 Using a dry brush rub in more ageing colour, and if necessary rub other areas smooth with sandpaper to reveal the darker colour underneath.

Techniques

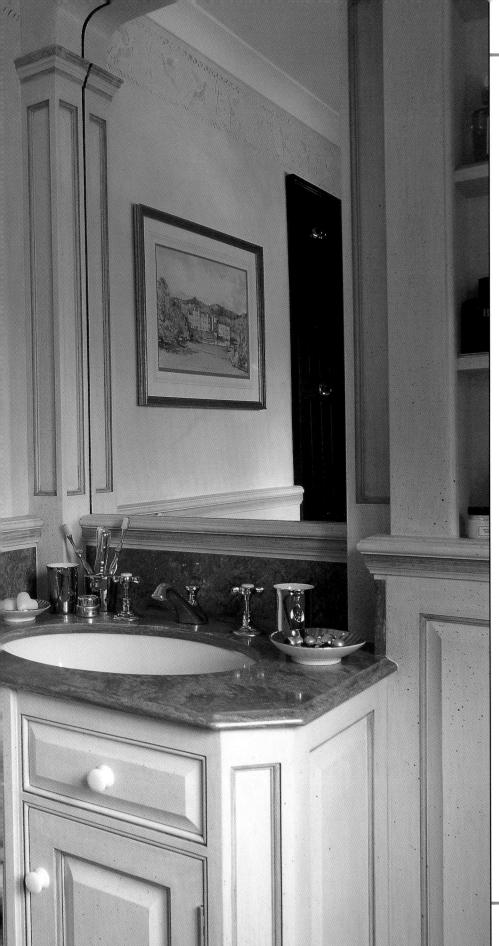

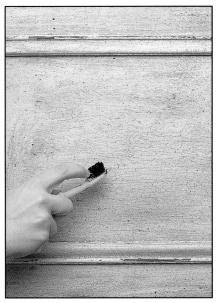

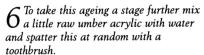

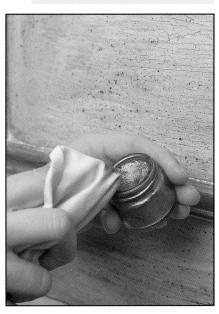

Add some finishing touches by picking out areas with a further colour. Here, we have used a gold wax pigment.

LEFT: The subtle use of the distressing technique on this bathroom sink unit shows how effective the finished results can be.

Rub the wax pigment on and in with a rag, or mix the wax with a little white spirit and paint the mixture on.

CRACKLE GLAZING

ive a favourite poster or picture an authentic antiqued look using the crackle glaze technique. Although there are a number of ways to achieve this 'craquelure' effect, it is easiest to use a proprietary cracking varnish, available from most artists' suppliers.

Basically the size of the cracks depends on the time you wait between steps 1 and 2. The longer the time gap, the smaller the cracks will be.

If you use a proprietary cracking medium, you may not need to use a hairdryer as the cracks should appear within an hour.

At this stage you have to look carefully for cracks. These will be enhanced by the ageing colour. Once you are happy with the cracked effect, squeeze some raw umber on to a piece of card or tray, and mix with a tiny amount of white spirit until you have a smooth paste. (As an alternative you can experiment with other colours like terre verte.) Apply the paste over the whole area rubbing it gently into the cracks with soft cotton wool. Then clean the excess off with a clean piece of cotton wool. Leave the surface to dry completely and protect the area with a coat of oilbased varnish.

Seal the picture with a colourless oil-1 Seal the picture with a colour based varnish and leave it to dry overnight. Once dry, apply a second coat of oil-based varnish thinly and evenly.

When the second coat is tacky, but not sticky (1/2-3 hours) apply a thin, even coat of water-based cracking varnish with a clean, dry, soft brush.

3 If no cracks appear after about 30 minutes, gently heat the surface with a hairdryer. As soon as some cracks do appear, stop heating.

4 After the cracks have appeared leave the picture to dry for a few hours, then mix a little white spirit with a little burnt umber in artists' oil.

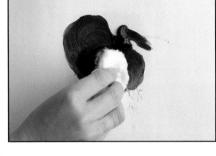

5 Take a lump of cotton wool and gently rub this mixture into the cracks.

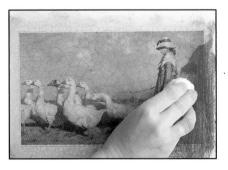

Remove the excess mixture with clean O cotton wool.

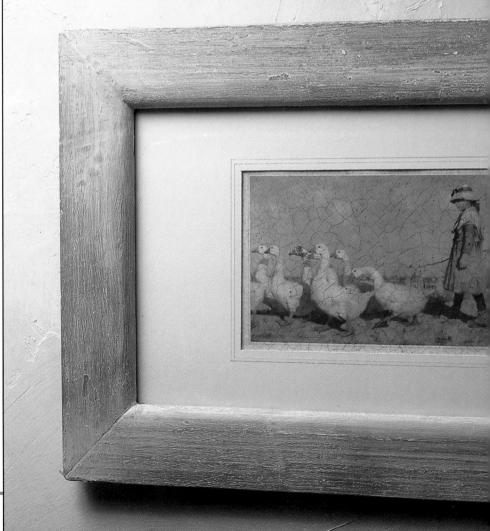

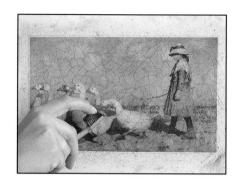

7 To enhance the aged look, use a toothbrush to spatter the surface with a mixture of white spirit and raw umber.

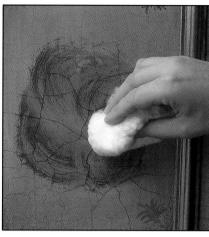

1 For an alternative look, work a light mix of raw umber into the cracks.

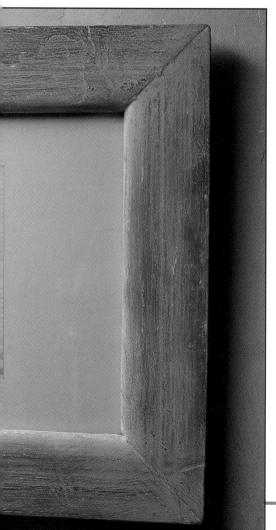

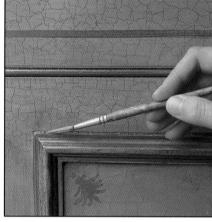

2 The crackle glaze effect also works well when highlighted with another paint colour. Gold is used here, but a deep red is also very effective.

RIGHT: The same effect has been applied to a piece of furniture which has been made from MDF (medium density fibreboard), but the technique has worked so well it could almost be an antique.

LEFT: The poster here has been treated with crackle glaze, while the frame has been treated with the alternative cracking method on pages 38–39.

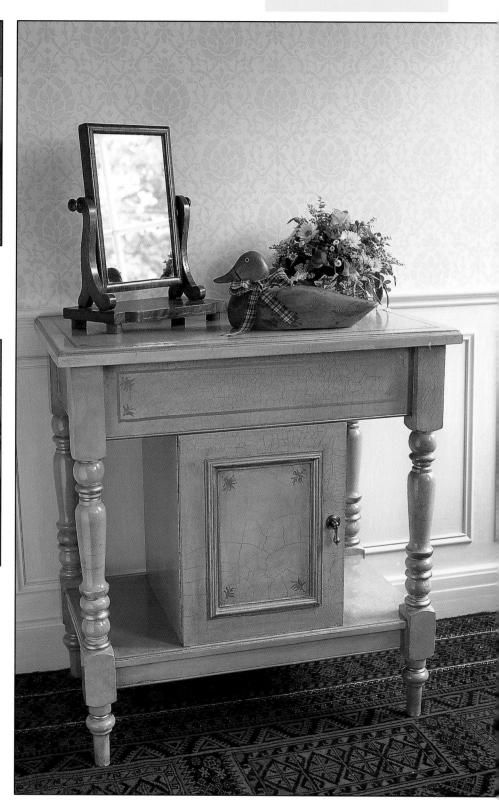

MARBLING

his is a classical technique which should be used selectively to be convincing. It is best done on areas which might have been made from the real thing, such as fireplaces or architectural details. For inspiration it helps to have a piece of real marble or a photograph at hand. Rather than recreating the piece accurately, be inspired by the general feeling of the marks and colours. Most importantly, don't overdo it when you are marbling. If you reach a stage that is satisfactory, leave the area to dry overnight and if necessary work on the effect the next day. Any mistakes can then be wiped off. Good preparation and a smooth surface is essential. It is best to work on a smooth oil-based surface.

This section shows a variety of ways to achieve a marbled effect. You can use a combination of these marks. An ideal glaze is 50 per cent scumble or oil-based varnish with 50 per cent white spirit, then add the artists' oil colours of your choice.

Most people find veining the hardest to do. It is important to avoid wormy-looking veins; they should be aggressive-looking. A way of making the veins less contrived is to use the hand you do not normally work with. Protect the finished effect with two coats of oil-based varnish.

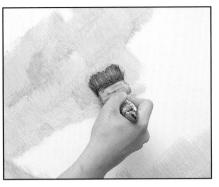

1 Working on a white basecoat, mix a little raw sienna with the glaze and apply it in patches, moving diagonally across the surface.

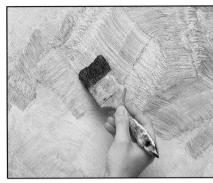

2 Mix a little grey with more of the glaze, and fill in the remaining areas, feathering the two colours together to blend in places.

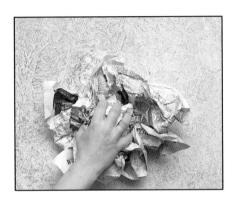

3 Take a rag or newspaper depending on the effect required, and dab the painted area lightly in places.

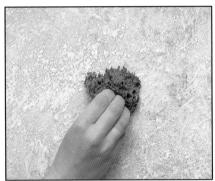

4 Dip the tip of a damp natural sea sponge into white spirit and dab some areas of the surface. This causes the glaze to spread, so be careful not to overdo this.

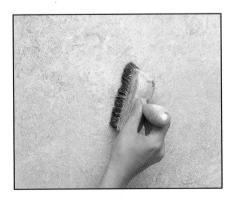

5 Using a soft dusting brush, very gently soften and blend the effect.

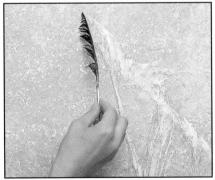

6 Pull a feather dipped in white spirit across the glaze in diagonal movements. This is called negative veining.

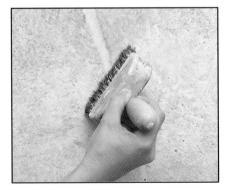

Soften some areas of this veining. The sharper marks you don't soften will look as if they are on the surface.

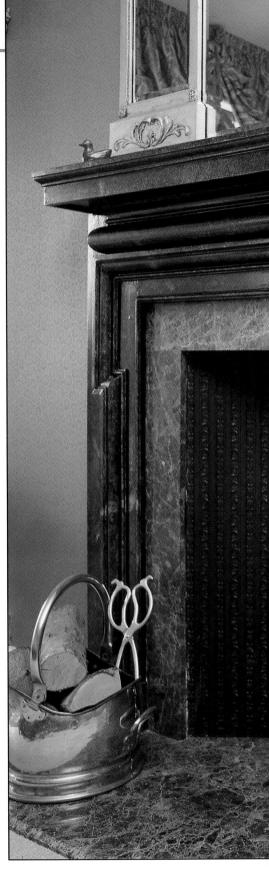

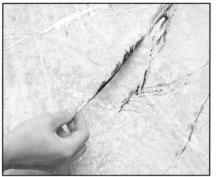

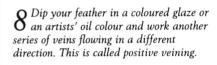

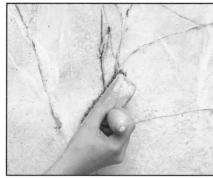

9 Again soften some areas of this veining to give the feeling of depth.

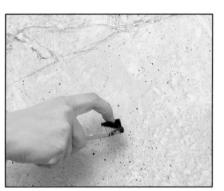

10 Spatter some white spirit or colour on to the area, to disperse more glaze or to apply more colour.

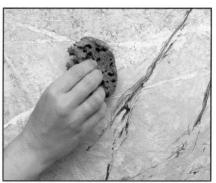

11 If necessary you can dip the sea sponge into a coloured glaze and sponge on more colour.

LEFT: Here, an inexpensive wooden fire surround has been painted with a marble paint effect, and looks incredibly realistic.

LEFT: The marbling paint effect usually works best on areas which may have been made from marble. The lampbase here is perfect for this treatment.

43

MARBLING PANELS

ne of the most important things about achieving a solid marble feel is the final varnish. At least two coats of gloss or satin varnish will enhance the look. But if you want to take the effect further by creating a panelled look, use a tinted glaze and work this over the marbled paint effect before varnishing.

Firstly choose the panelling you want, making sure that the size is relevant to the object itself. There are more designs on page 108, or use one of the designs here.

If you are still finding it difficult to decide on the type of marbling you want it may be best to consult architectural or art history books in the library.

Generally a panel is created over a marble paint effect. Once you have marbled the area, leave it to dry, then experiment with different marks, a variety of tinted varnishes and unusual washes.

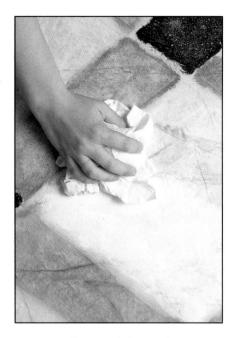

1 Mask off the panel shapes. Then mix an oil-based varnish with white spirit and tint. Apply this to some panels using a rag, allowing the underlying marbling to show.

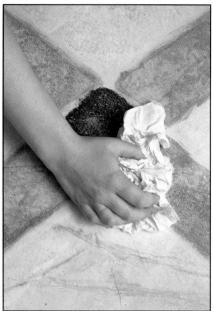

2 Repeat the process on the second larger panel, but use a different coloured varnish. Here, grey is used.

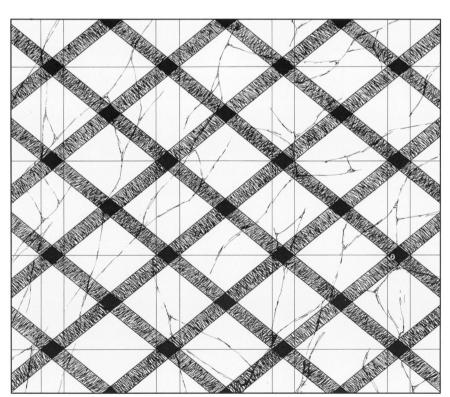

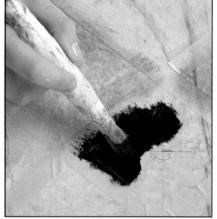

3 The smaller diamonds can then be picked out in another colour (black).

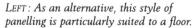

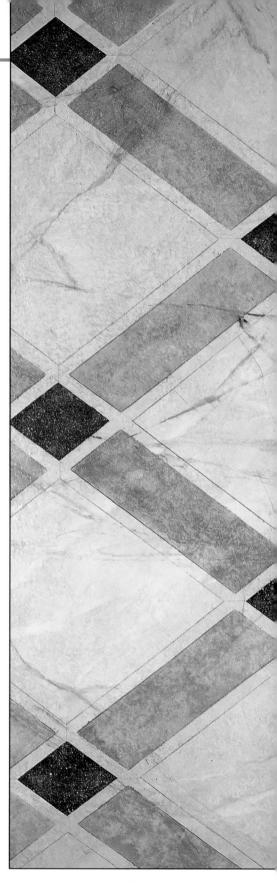

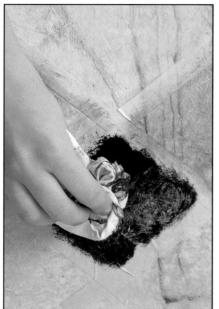

4 When using black, rag off some of the colour with a soft cloth to take the colour's harshness away.

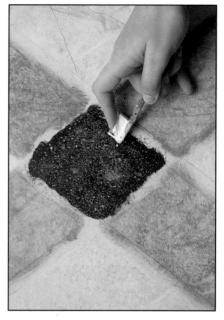

5 While the black is still wet add another effect, by dipping a toothbrush in white oil paint thinned with white spirit and spatter this over the black area.

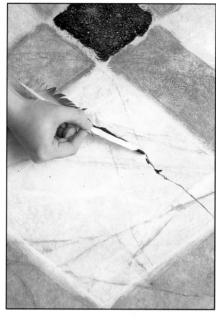

6 Another natural effect you may wish to try is to add some more veins with the feather, or even to highlight the ones which are underneath.

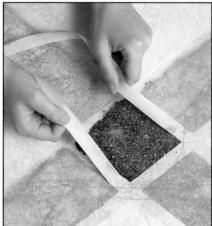

When the glazes have dried a little, but are not completely dry, carefully peel away the masking tape and wipe off any excess glaze with a rag.

LEFT: This is one of many different panel designs which could be used when creating a marbled panel effect.

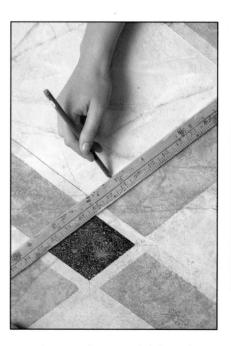

Before varnishing use a hard pencil to pick out the shapes more clearly, if you want.

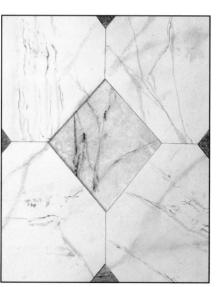

ABOVE: The paint effect panels here would work well if used for a flooring especially in a kitchen or bathroom.

VERDIGRIS

his is the natural result of condensation on copper, bronze and brass, which in the past has been used for making green pigments. The green-blue deposit, although toxic, has a wonderfully pure look about it, and coupled with the ageing air it achieves, it is an important effect to try and imitate. It is also a super technique to experiment with and will work on a variety of surfaces. This is a good technique to use on small decorative items as well as larger architectural features, such as the staircase seen in the main picture.

Mix the colours you need using acrylics or buy water-based emulsions and tint them with acrylics to obtain the colours. Protect the finish with oil-based varnish.

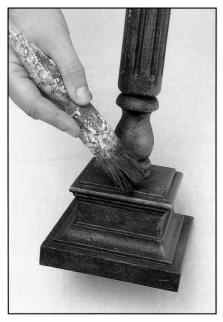

1 Spray or paint the object with a base colour of copper, gold or bronze. Then, leave to dry. Now, using a small brush stipple the darker colour all over the object.

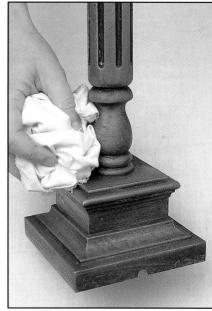

2 Using a rag, dab and stipple the paint lifting it off in some areas, and leaving it on in others, particularly in recesses. Leave to dry.

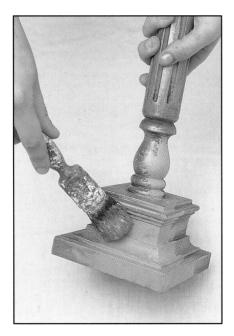

3 Using a small brush, add the second lighter colour on top of the first, again working a random effect.

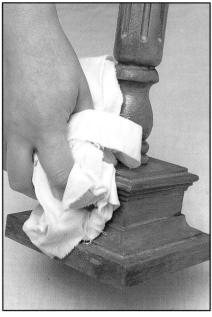

4 Using a rag, dab some of the second colour off, exposing the first and bronze colours underneath. Leave to dry.

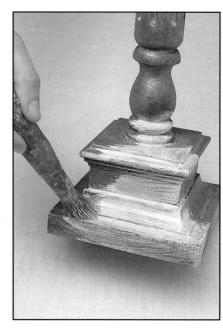

5 Using a small brush paint an off-white water-based paint thinned with 20 per cent water over the area.

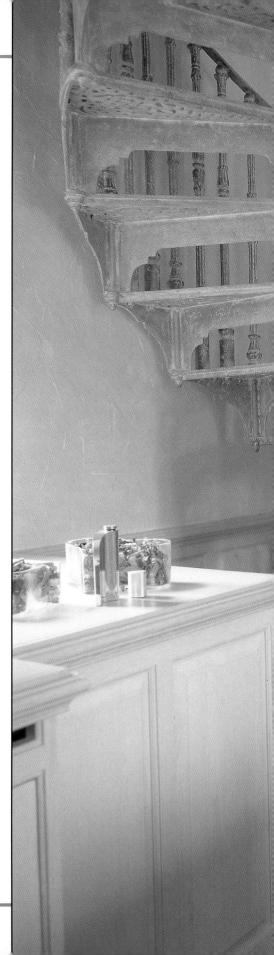

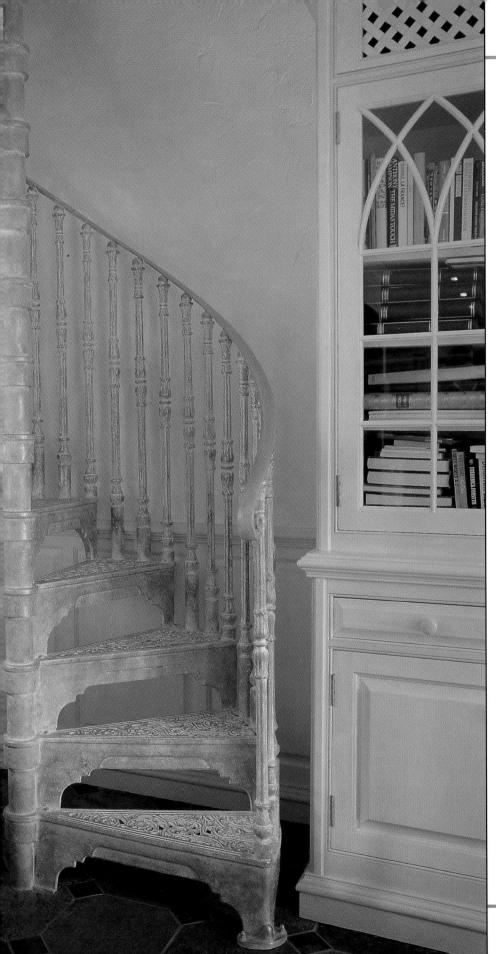

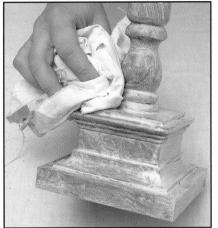

6 Immediately this is on, rag it off again leaving only traces of the white paint, particularly in the recessed areas, to give the object a dusty look. Leave to dry.

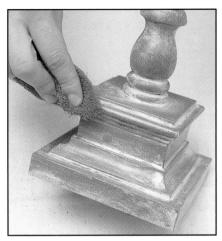

Rub the raised areas gently with a fine sandpaper or a kitchen scourer to expose more of the colours underneath.

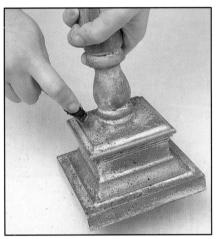

8 As a final touch, spatter a little raw umber on to the finished surface with a toothbrush.

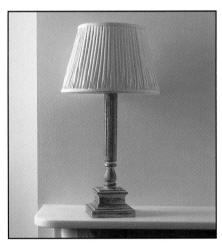

ABOVE: The final lampbase looks very effective once the verdigris treatment has been completed.

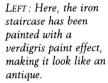

ABOVE: The paint colours which were used on the lampbase.

Techniques

TERRACOTTA

his weathered terracotta look is easy to create and can even be painted on to walls if used sensibly. The terracotta look works particularly well on small objects such as the plastic urn which has been treated here.

When working this technique it is best to use either water-based emulsions or acrylic paint colours. You will also need some sand, which you can pick up at a beach or a local home handyman store and a rough, natural sea sponge.

Detailed or moulded items also look particularly attractive when finished with a terracotta effect, especially if they are going to be used in a conservatory or garden room. Protect the finish with a coat of oil-based varnish.

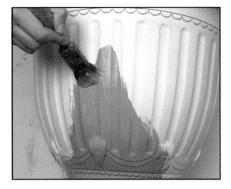

1 Place the object on a newspaper or old sheet then paint with the lighter colour.

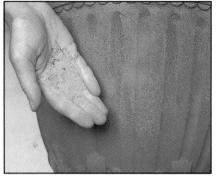

2 While the paint is still wet, throw the dry builders' sand on to the wet surface, creating a random patchy finish.

ABOVE: The basic palette.

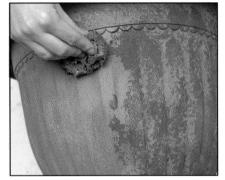

3 Sponge patches of the darker colour over the object at random making sure you leave some of the paler colour showing through.

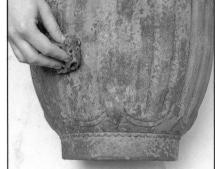

4 Roughly sponge an orange, water-based paint on to the object. Leave to dry.

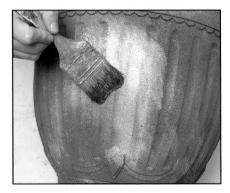

5 Mix up an off-white water-based emulsion with 70 per cent water, and apply mix randomly over the plastic urn.

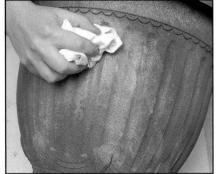

6 Rub any excess wash off with a rag, leaving enough to create a dusty look.

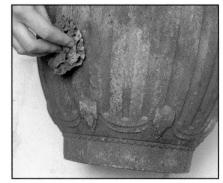

7 As an option the aged look can be enhanced by sponging a turquoise blue colour over the urn.

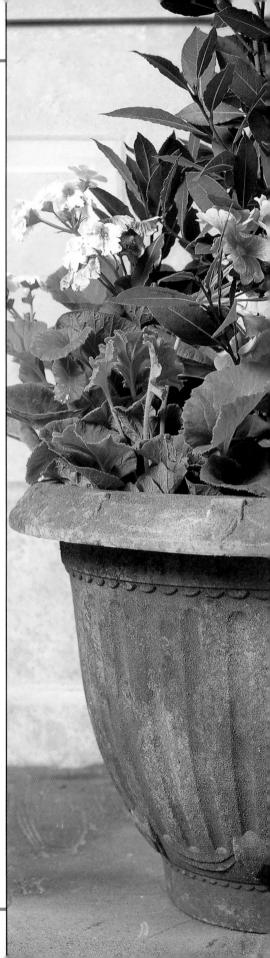

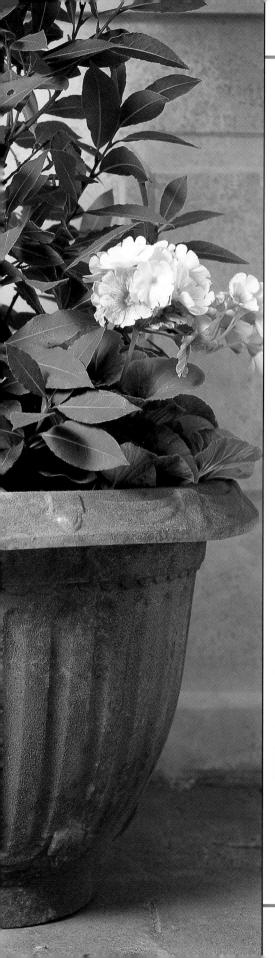

LEAD

his is a particularly good technique for adding visual weight to an object, giving it a much more solid appearance. This is a great paint technique when working on displays and presentations, as the surface always looks so much more solid and dense, so the technique is often seen on display stands at exhibitions.

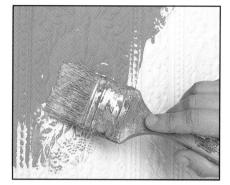

1 Paint the surface using a mid-grey water-based emulsion or acrylic paint and leave to dry.

Hold a silver spray can about 30cm (12in) from the surface and tap the top gently with a piece of wood. The paint will spatter out of the can in patches.

LEFT: A plastic urn treated with the terracotta paint effect looks as effective as the real object.

ABOVE: A close-up of the lead paint effect shows how well this technique works on moulded areas.

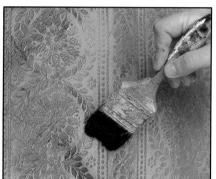

3 Mix up a black water-based emulsion with a little water and rub into some areas with a brush.

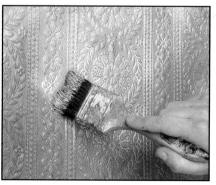

4 Mix up a wash of off-white emulsion using 60 per cent water and rub into the surface blending it in in some areas.

RUST

his technique works very well on garden ornaments where it would be found naturally, and is used on lamp bases in the home. It is often seen on seats or ornaments which are then used conservatories. Wherever the technique is found it has an almost theatrical, rich look.

Use water-based emulsions or acrylics to work the effect. Once again the finished surface should be protected with a satin or matt oil-based varnish.

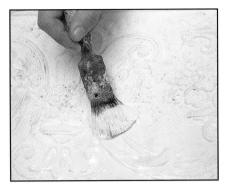

1 Apply a thick coat of water-based emulsion over the whole area. You can use any colour for this.

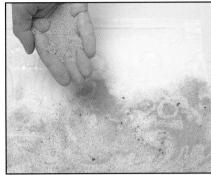

2 Immediately sprinkle sand over the thick coat of paint and leave the surface to dry completely.

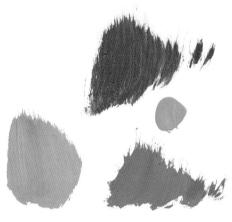

3 Using the dark brown colour, stipple and fitch the painted area, leaving some of the surface untouched by brown paint.

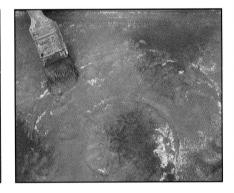

4 Fill in the remaining areas of the painted surface with the terracotta colour, again stippling and fitching the paint while you are working. Leave to dry.

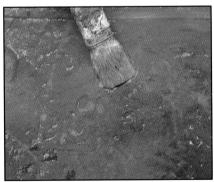

5 Sprinkle the area with water, and stipple small areas of the surface with a blue-grey colour. Leave this to dry.

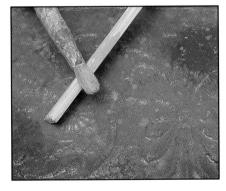

6 Again sprinkle the area with water. to ensure the paint will merge to give a more natural overall effect. Then spatter the area with orange paint.

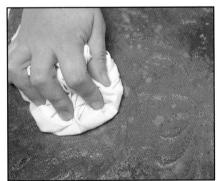

Using a rag, remove any excess water. Carefully merge some of the effects and leave to dry.

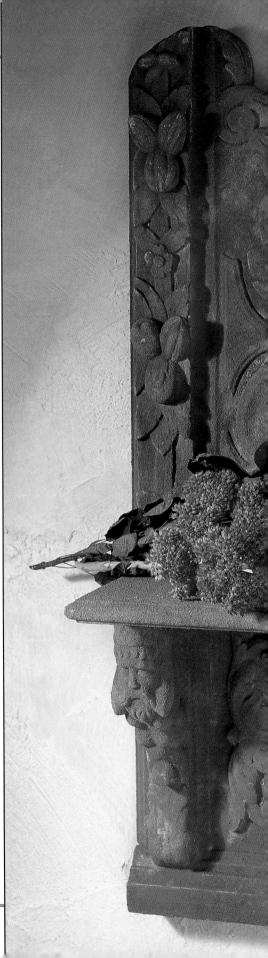

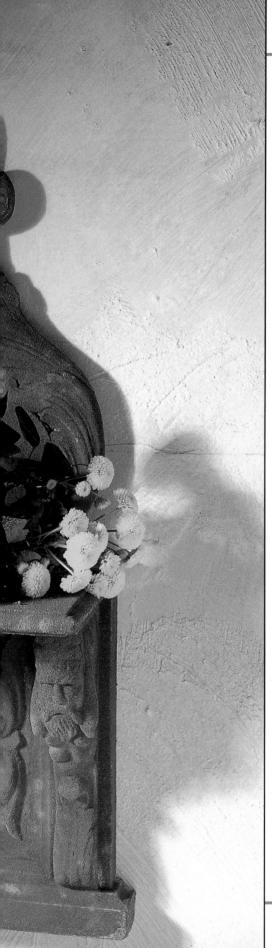

PEWTER

his is another technique which works well on small items, which may have been made from pewter in reality. Spray paints are ideal for creating this effect, but they must be used in well-ventilated areas, and it is also a good idea to wear a mask.

To help the paint run smoothly add some liquid detergent to the mixture.

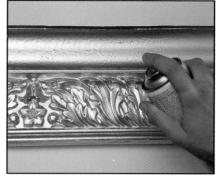

1 Spray or paint the object silver and leave to dry.

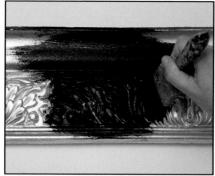

2 Fitch dark grey water-based emulsion or acrylic over the area and into any detailed mouldings.

LEFT: The rust paint effect has been applied to an old piece of carved wood transforming it into an attractive and stunning showpiece.

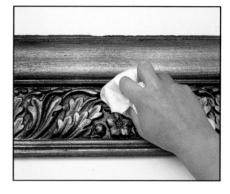

3 Wipe off any excess paint with a soft rag.

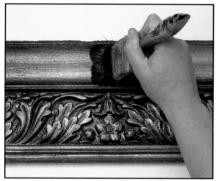

4 Take a dry brush and rub the area hard to distress the remaining black paint into the silver surface.

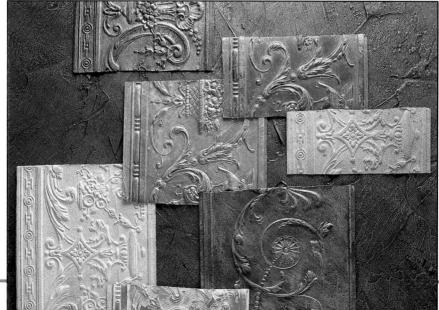

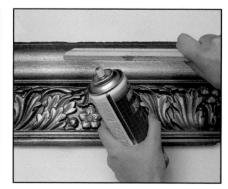

5 Add the finishing touches by spattering silver paint on with a toothbrush or by tapping the top of a silver spray can with a piece of wood.

Techniques

IMITATION GILDING

his is a very popular paint technique which can be used to give almost any object an embellished or highly gilded look, depending on the desired effect. The technique uses gold wax and fine tissue to create the effect, although it can be done in a variety of ways. This method is one of the simplest and cheapest and achieves good results time after time.

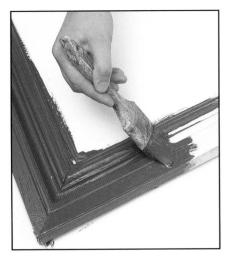

RIGHT: This is an example of how sumptuous and sophisticated gilding can look worked here in this small alcove.

1 Paint or spray the object with a red oxide metal primer or a brown/red oil-based eggshell or undercoat.

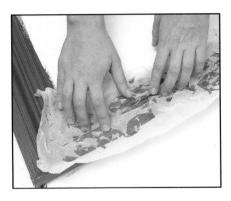

While the paint is still wet, lay on several layers of fine tissue paper, overlapping and bunching the tissue paper as you lay it on to the object.

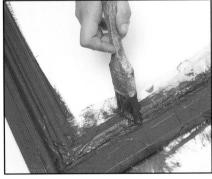

3 Using a brush and paint, flatten the tissue out, building up creases and crevices, and ensuring some tissue fits into recesses and moulding. Leave to dry.

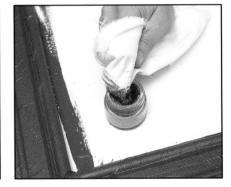

4 Now apply the gold. Either use gold wax, spray paint or paint. One of the easiest ways to add gold is to rub on gold wax using a soft cloth.

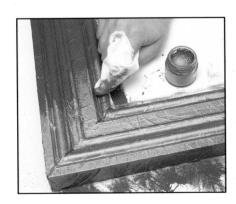

5 Ensure the gold wax or paint covers the object and the moulded areas.

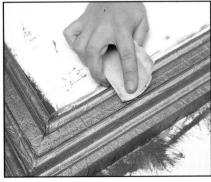

6 Once the object is completely covered, rub the surface using a soft cloth. Using fine sandpaper remove some of the gold paint to reveal the colour underneath.

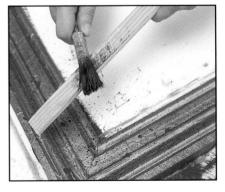

Spatter some of the original colour on to the surface using an old brush and a piece of wood, then leave the paint to dry.

METALLIC

A lustrous metallic effect can be achieved cheaply and effectively using proprietary spray paints. These must be used in a well-ventilated area, and you should also consider wearing a mask.

The idea is to build up layers of different coloured metallic car spray paints to achieve a sense of depth.

The colours can be sprayed in any order, but the last colour sprayed will usually be the predominant one. Try to avoid the spray going on to your skin by placing the hand which is holding the object into a polythene bag.

You can enhance the effect by adding a stencil motif on to the surface. Keep stencils in place with spray adhesive, which also helps stop the paint seeping under the stencil.

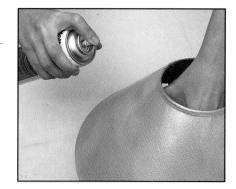

Holding the object securely, spray the first colour over it. Try to spray the paint fairly randomly.

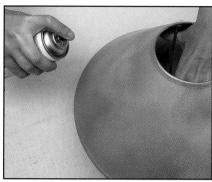

2 Using the next colour spray, coat the object randomly with this colour.

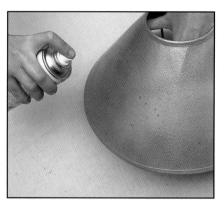

3 Add another colour maintaining the random effect of colour.

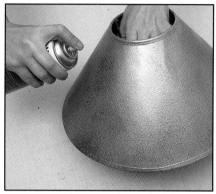

4 Finally, spray the last colour over the object, remembering that this will be the predominant colour.

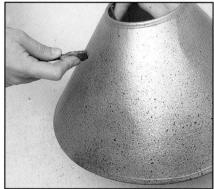

5 Add a finishing touch by spattering a darker oil-based colour on to the object.

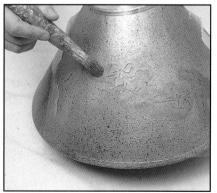

6 The effect has been enhanced with a stencil stippled on to the surface using a gold wax paint.

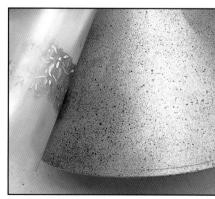

Carefully remove the acetate stencil, before the gold paint has completely dried.

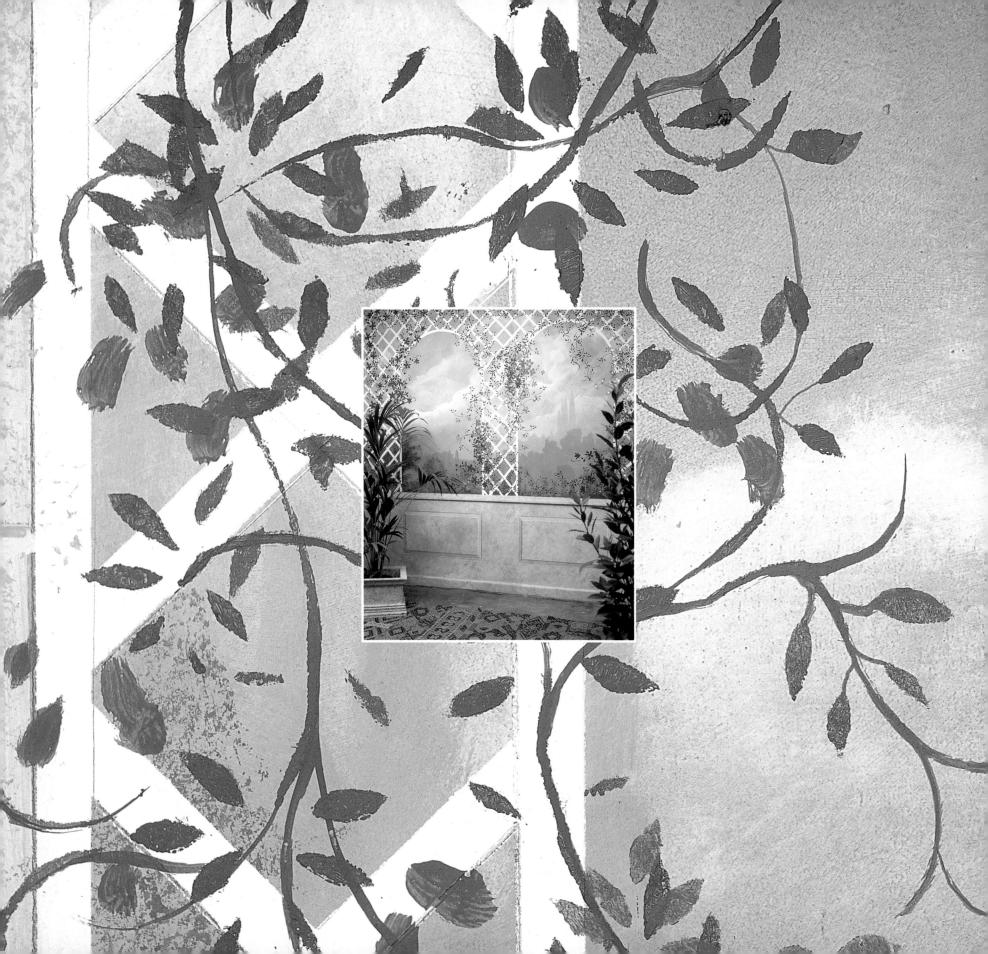

Using the techniques taught in the previous section, here are a range of amazing decorative effects created with paint.

Many of the techniques have been used in conjunction with each other to maximize the options open to you and to show how versatile each of the effects are. It is important to try to use your own creativity when planning projects for your home. Use the ideas and suggestions you find here as inspiration, and then create your own unique designs.

MURAL

his mural was created for a conservatory wall, where it adds three-dimensional interest, and looks highly effective. The paint effect may look fairly daunting at first, but once it is broken down into simple stages, it is not difficult to achieve. All it takes is a little confidence, and a few everyday materials.

When attempting a project like this, try to incorporate any architectural features that already exist in the room in to the paint effect. If there are none you could add some features of your own. Here, for example, the dado rail and skirting board have been made to look like part of the stone wall.

You can add depth to the scene by varying the colours and sizes. The larger plants in the foreground, add depth and help to enhance the finished look.

To create this mural you need waterbased paints in the basic colours given opposite. The first thing to do is to paint the whole surface in a mid-blue or cornflower blue, water-based emulsion then leave the area to dry totally.

A good general hint when working on a scene or paint effect like this is to stand away from the painting occasionally so that you can check that you are creating the effect you had planned.

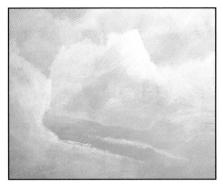

1 Wet the dry blue surface with water.
Use a small brush to mark out the cloud shapes with a thinned white emulsion paint.

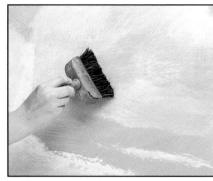

2 To create the three-dimensional effect you need to soften some of the clouds using a soft dry brush, and enhance the tips of others with white paint. Leave to dry.

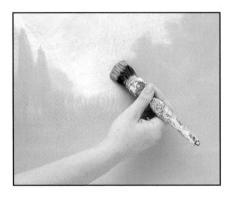

3 Using a small brush, paint the first background silhouette using a light blue-green colour.

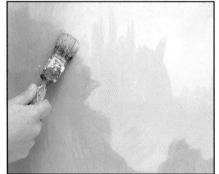

A Repeat the process using a darker bluegreen colour to enhance the background shapes. Paint the foreground trees using the same colour and leave the area to dry.

ABOVE: This is the rough cloud outline used here. Individualise it for your own scheme.

ABOVE: Use this pattern as the basis of the general background shapes worked here.

ABOVE: This diagram is for guidance when enhancing the background shapes.

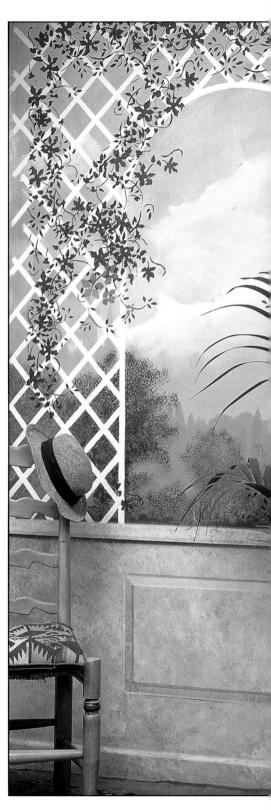

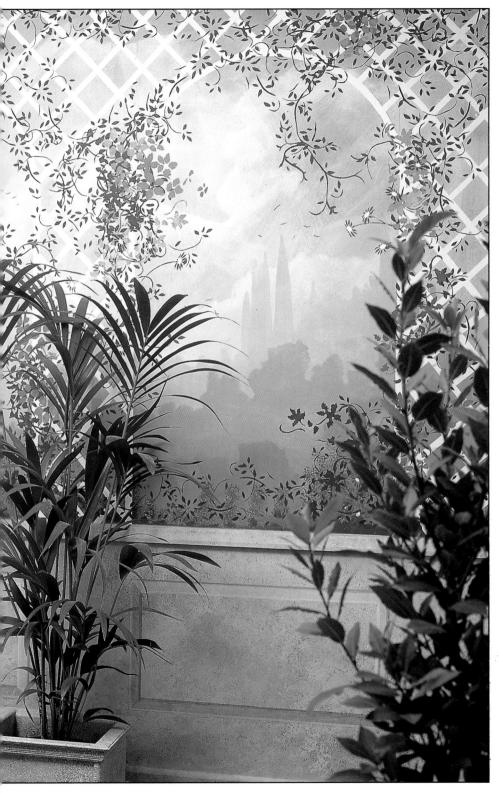

5 To create a misty effect apply a milky wash over the whole scene. Make up the milky wash with white emulsion thinned with 80 per cent water, then leave to dry.

6 Using a darker green paint, sponge on the foreground shapes. Use your imagination here to create hedges and arches.

Again using a sponge, add more interest to the foreground by painting flowers in bright colours: reds, yellows and oranges.

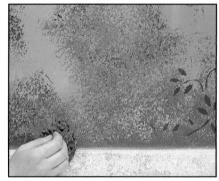

8 Using the same sponge, blend in the colours to soften the effect.

ABOVE: The range of colours used to create the mural background.

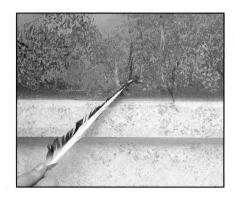

9 Another method of painting the foreground is to use a feather. This will make unconventional marks. Finally use stencils to create the border in the distance.

Once you have reached this stage you can transform the scene you have created into a view.

Some of the best scenes are seen through a window or a door, for example, but you could also consider creating an attractive trellis, which is the solution here. Painting a trellis gives you the opportunity to give even more of a three-dimensional effect to the scene by stencilling a trailing plant under and over the trellis.

RIGHT: A gothic door is one way of giving depth to the scene. For styles of architecture consult books in the library.

BELOW: A trellis effect has been used here to give a three-dimensional effect. It helps to create depth to the painted area.

10 Using the trellis design for reference, mark out the size of the trellis using a soft pencil and ruler. Check all your lines are straight.

1 1 To draw in the semi-circles, tie a pencil to a length of string and pin the string at the middle point of the circle. Pull against the string as you draw.

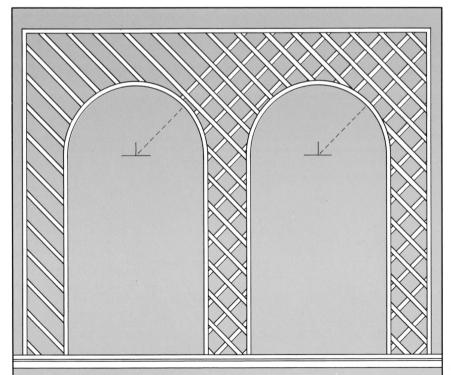

12 Using low-tack masking tape, mask the areas so you can paint the semicircle shape and vertical lines.

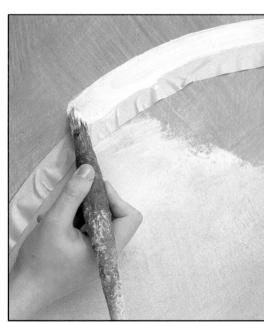

13 Paint in the lines using white waterbased emulsion paint, and gently remove the masking tape while the paint is still wet. Leave to dry.

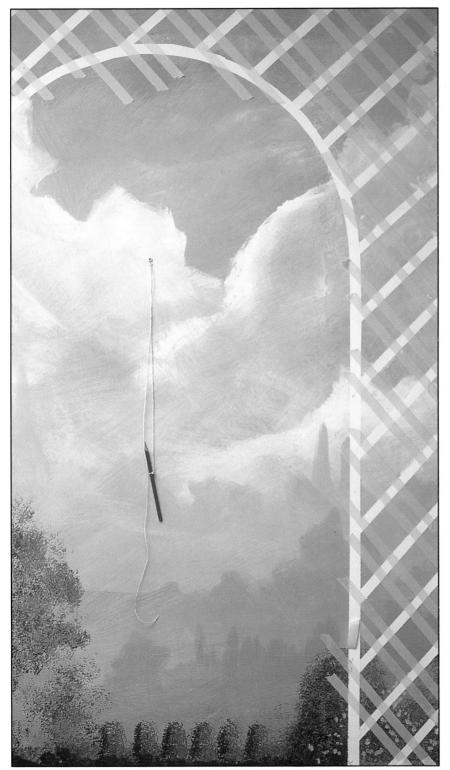

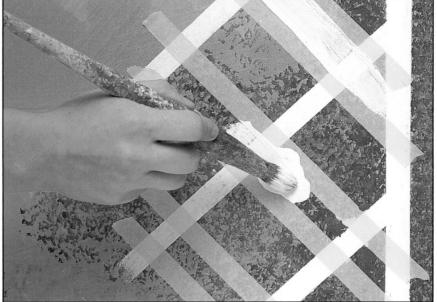

14 Once dry, mask off the diagonal trellis shapes, then paint with the white emulsion. Remove tape and again leave to dry.

 $15\,$ Mask off the opposite diagonals, paint with white emulsion, remove the tape, and leave to dry.

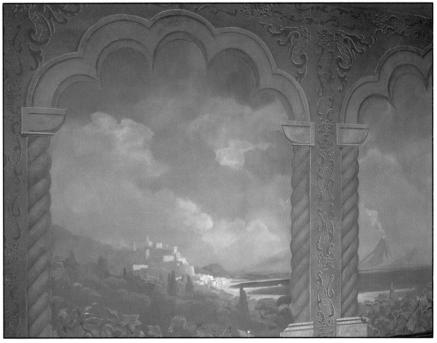

Above: As an alternative you can use a more advanced architectural arch. This arch looks out on to an imaginary landscape.

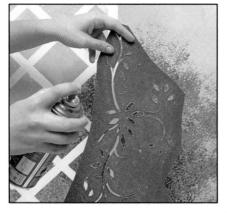

16 Use the template on page 103 to make a stencil from thin acetate. Apply spray adhesive and position. This leaves both hands free to paint.

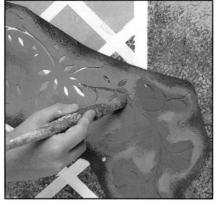

17 Mix up a range of greens using olive green and terre verte. Add a little raw umber or white to darken or lighten the colours.

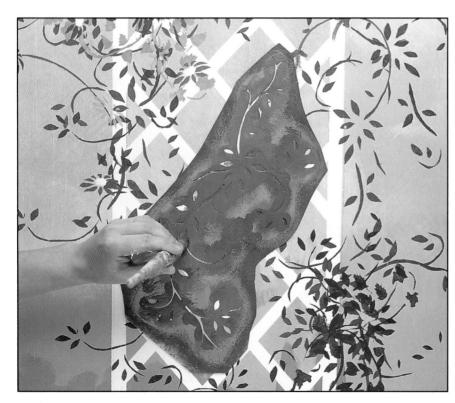

18 Using this range of colours stencil a trailing effect over the trellis, building up some areas of foliage and leaving some parts almost bare.

RIGHT: Adding a trellis creates a different look and gives a totally new dimension to the garden room.

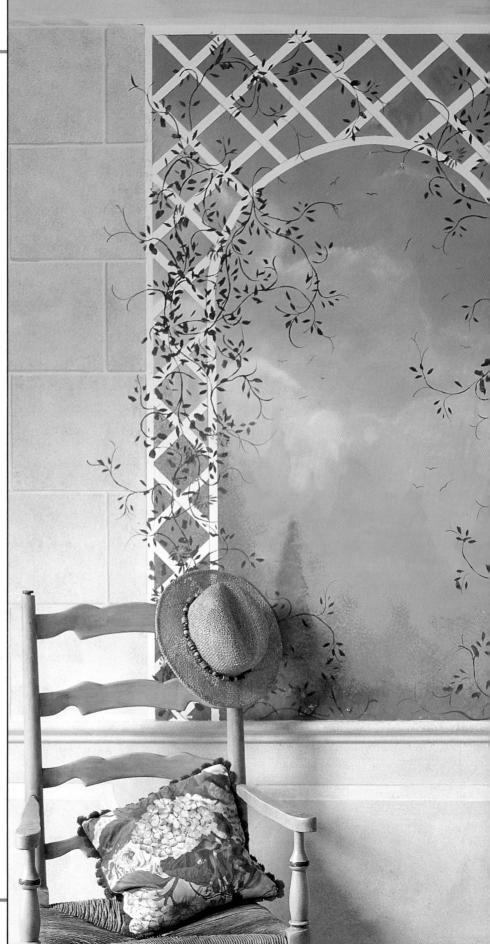

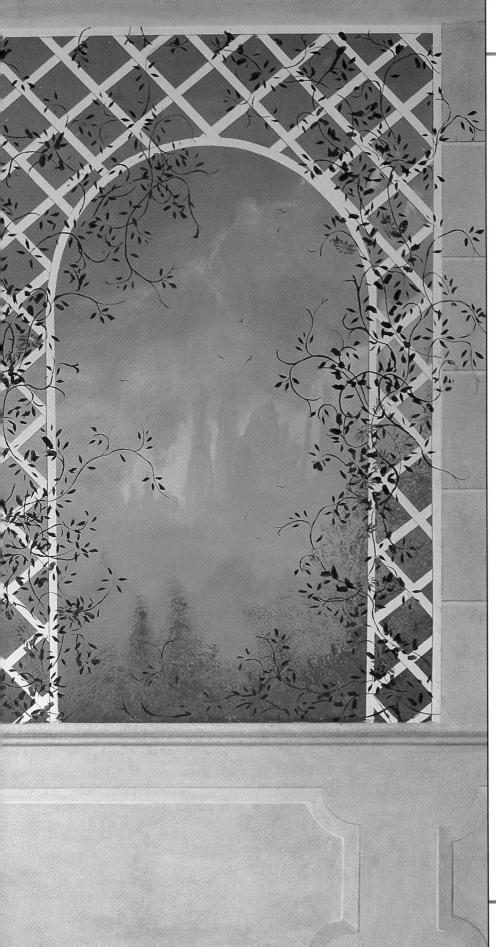

19 Leave the stencilled leaves to dry, then add some stencilled flowers using primary colours mixed with raw umber or white to give different intensities.

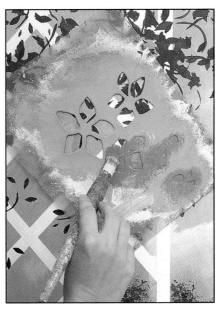

20 Add some different flower shapes for some more contrast and variety.

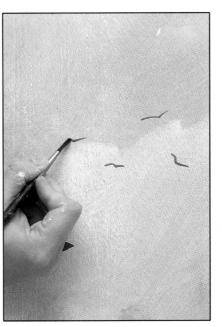

21 Paint finishing touches by adding the suggestion of birds in the distance. Use a dark grey paint and a small brush and flick two lines to create the birds.

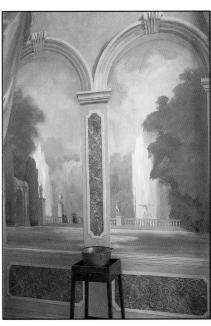

ABOVE: With practice and experience the results from these simple steps can be totally stunning.

MURAL BASE

here are a number of effects which work well as the base for a mural. A marble or stone wall can be created easily, while brickwork is also effective. A stone or brick effect is created using a natural sponge and proprietary emulsions in the correct colours.

When working on the base include the dado and skirting boards, as this makes the base look more solid.

ABOVE: Mix the stone colours using acrylic paint, or buy small tins of emulsion.

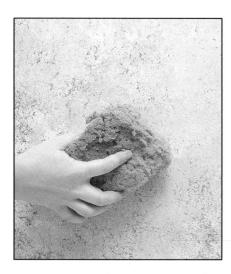

2 As the last colour you paint is generally predominant, finish the painting with the main stone colour.

1 Either use an old sea sponge or soften a new sponge by picking off any hard edges. Sponge the area at random using your chosen colours.

3 For the carved stone effect follow steps 10–13 on page 101.

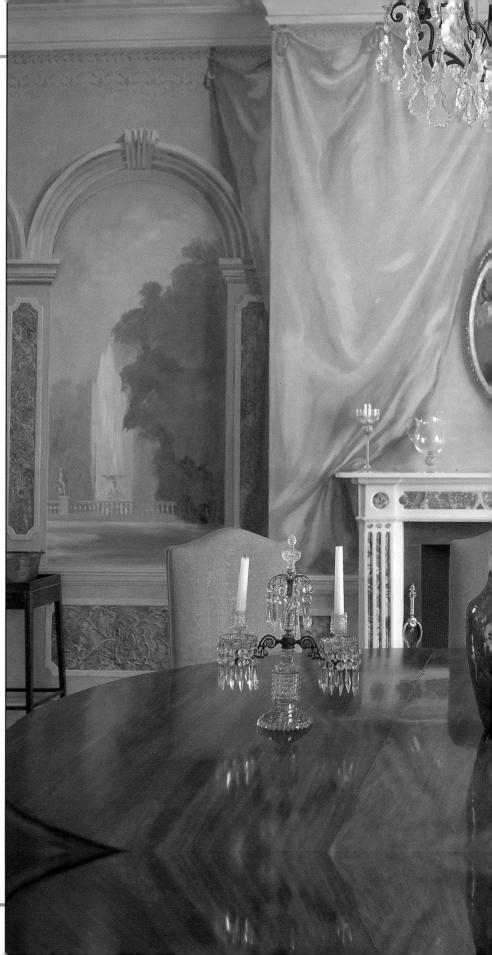

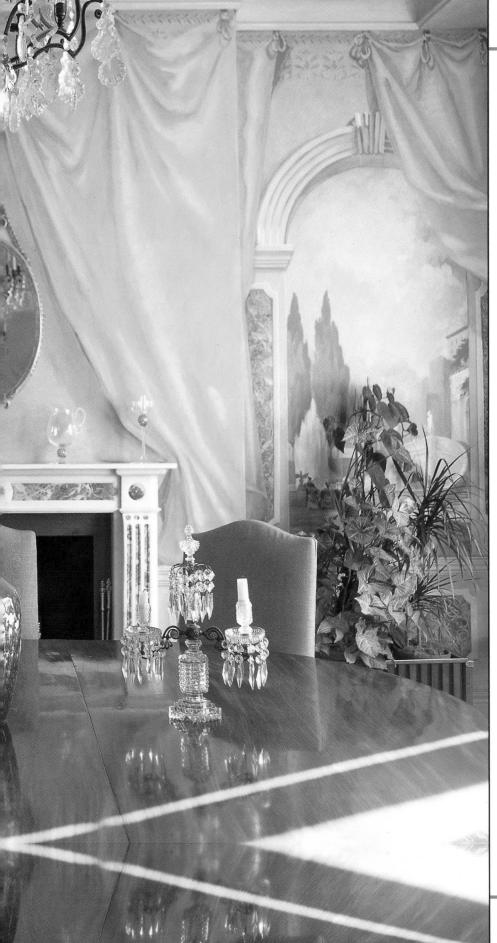

4 Alternatively, create an old, red brickwork effect by roughly sponging on the colours given, using a sponge.

5 Build up the effect by sponging on more red and terracotta colours, finishing with the final wall colour.

Once you are happy with the overall appearance, draw in the brick work.

Mark the horizontal lines using an off-white emulsion. Then fill in the verticals.

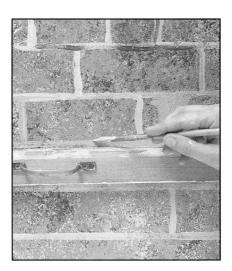

7 To make the brickwork look more effective, add some vertical lines which are not quite straight.

LEFT: These are the colours used for brickwork.

Doors

atterly people have devoted more and more time and expense to their fitted kitchen, bedrooms and bathrooms. Nowadays, there is a huge array of finishes which can be applied and the final look is limited only by your imagination.

As the trend is now for people to decorate their home in more unique ways, these finishes are used on a regular basis. It is not unusual to see kitchen doors finished with a pewter paint finish, or even to see heavily distressed finishes in bedrooms.

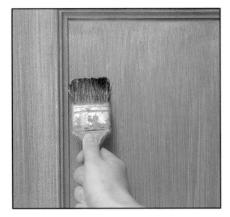

ABOVE: The dragged effect seen on the doors here is easily achieved using an old worn brush.

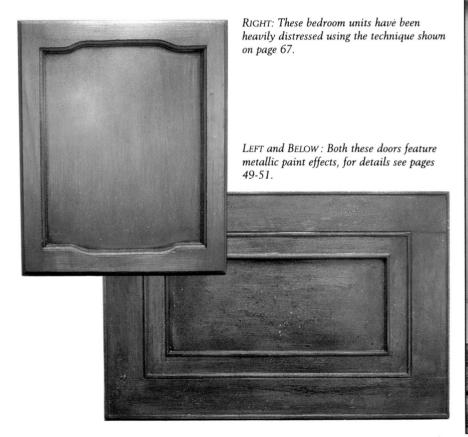

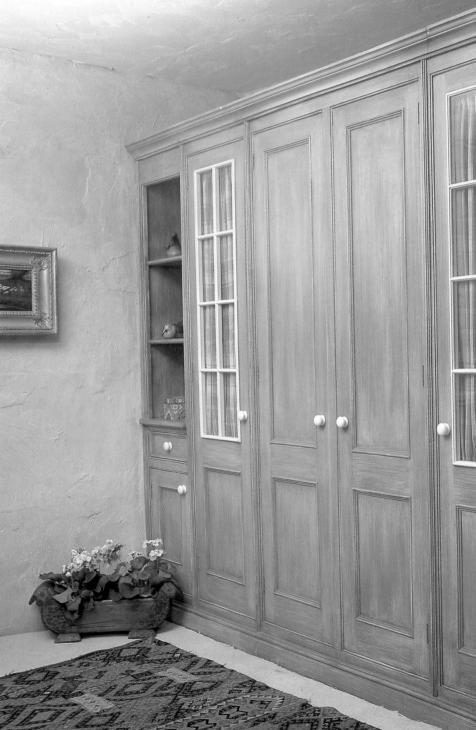

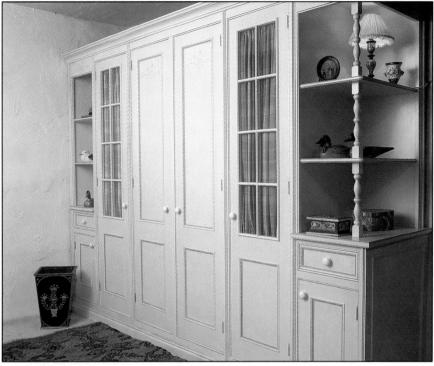

ABOVE: The door here has been treated with a limed effect, see page 33.

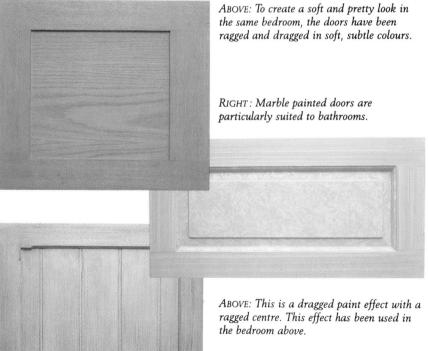

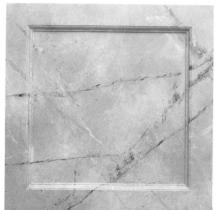

BLUE CABINET

reate a distressed, aged and washed out look on new furniture and wooden floors using a water-based emulsion. It will add interest to a piece, which otherwise would have simply blended into the background. Either use the colours given here or experiment with different colours.

The cabinet and little shelving unit worked on here were made in softwood and MDF(medium density fibreboard).

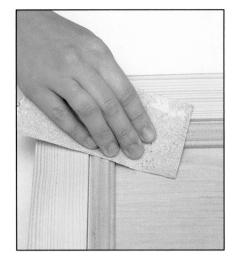

1 Rub down and smooth off any hard edges using a medium grade sandpaper.

ABOVE: The paint colours used for the cabinet.

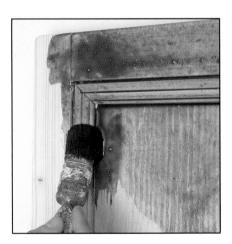

2 If you are working with a new item, stain it with a strong coffee mix. This will show through on the finished piece and looks more authentic than new wood.

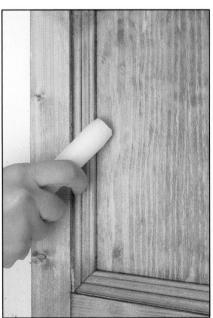

When dry, rub the raised areas and mouldings with furniture or candle wax. These areas will then resist subsequent layers of paint. Leave to dry.

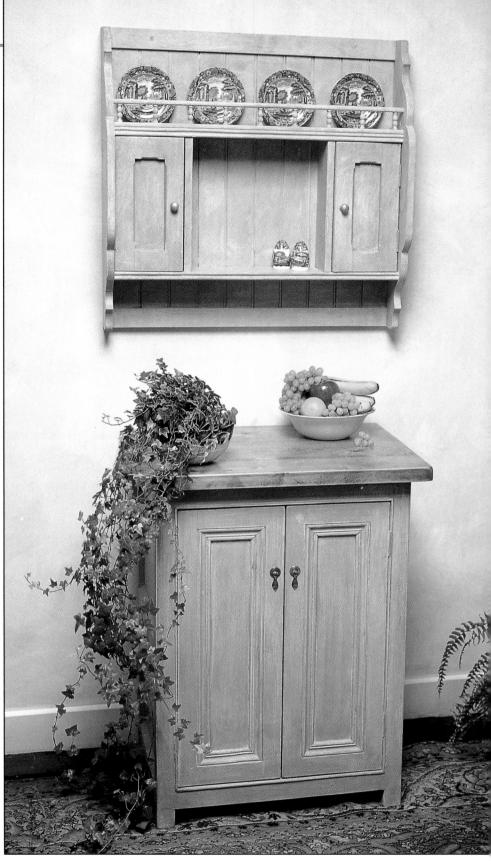

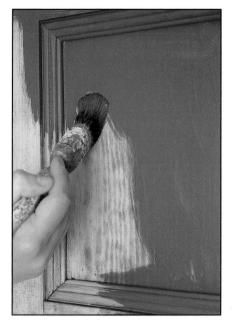

4 Thickly paint the object with the darker green colour. Leave to dry.

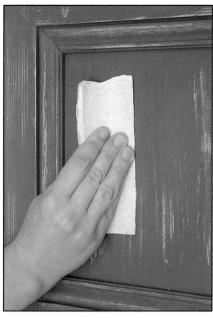

5 Rub the paint off in some areas using a medium grade sandpaper to expose some of the stained wood underneath.

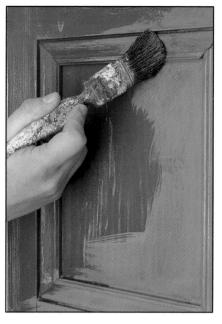

6 Thin the lighter coloured paint with about 40 per cent water and coat the object with this paint mixture, covering the mouldings and recesses.

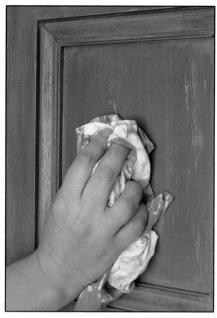

Before the paint has dried, use a soft rag to remove any excess paint and create a distressed look.

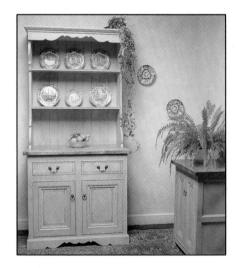

ABOVE: The same effect has been used on the dresser in this room.

LEFT: Ageing modern pieces adds real style to the room. The small cabinet was an inexpensive purchase, but with a little work it becomes a very desirable piece.

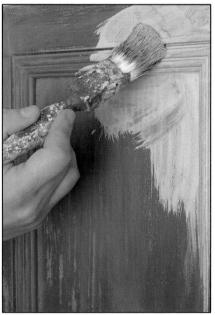

Apply an off-white wash, made with white emulsion and 50 per cent water over the whole surface rubbing into the recesses and mouldings. Leave to dry.

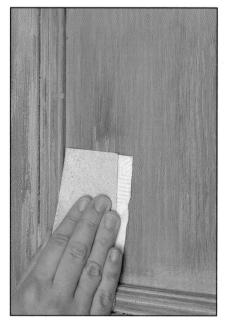

9 Using a medium grade sandpaper, reveal more of the underlying colour and stained wood. Work carefully at this stage.

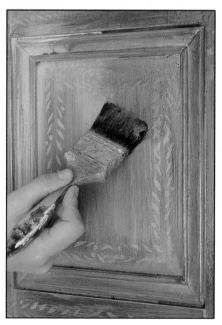

10 Once you are happy with the effect apply a coat of oil-based varnish tinted with a little raw umber.

BOXES

S maller objects respond well to the many different paint techniques. They also offer a good opportunity to experiment and try out some of the more unusual paint effects.

Here a selection of boxes have been

Here a selection of boxes have been treated to a range of different finishes. Some of the effects have also been enhanced with trims, such as gold painted lines or little stencil designs.

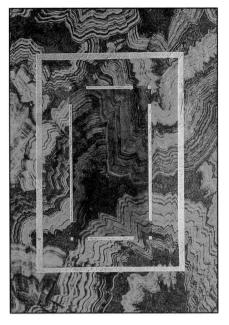

ABOVE: This jewellery box has been painted using a malachite-inspired paint effect (see page 36). This has been enhanced with lines of gold paint.

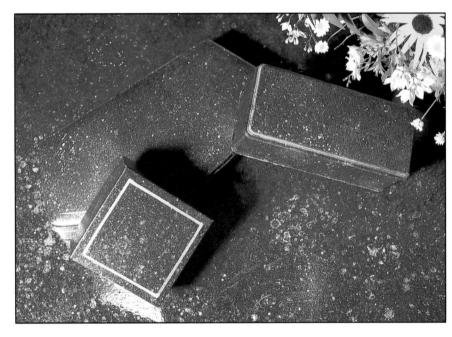

ABOVE: The lapis lazuli paint effect (see page 37) has transformed all the small boxes and the table top. Gold paint adds the finishing touch.

RIGHT: All the boxes and objects in this picture look expensive and exclusive, but in reality they are all painted using a variety of techniques.

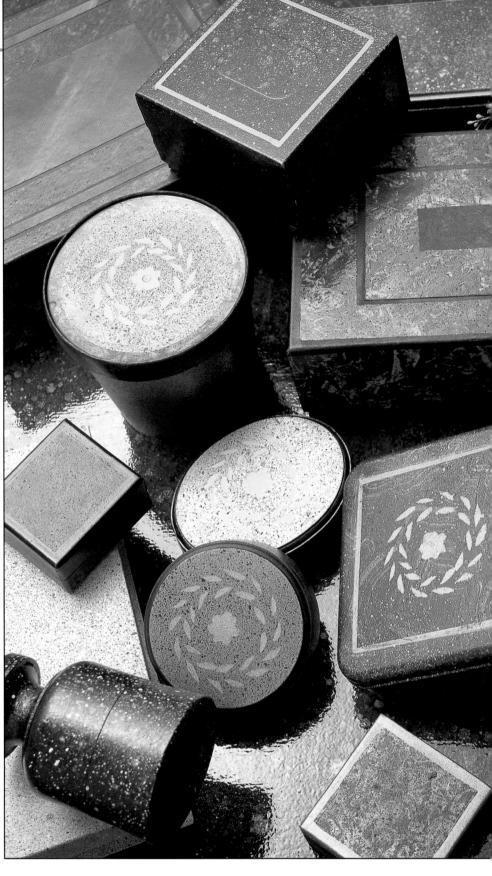

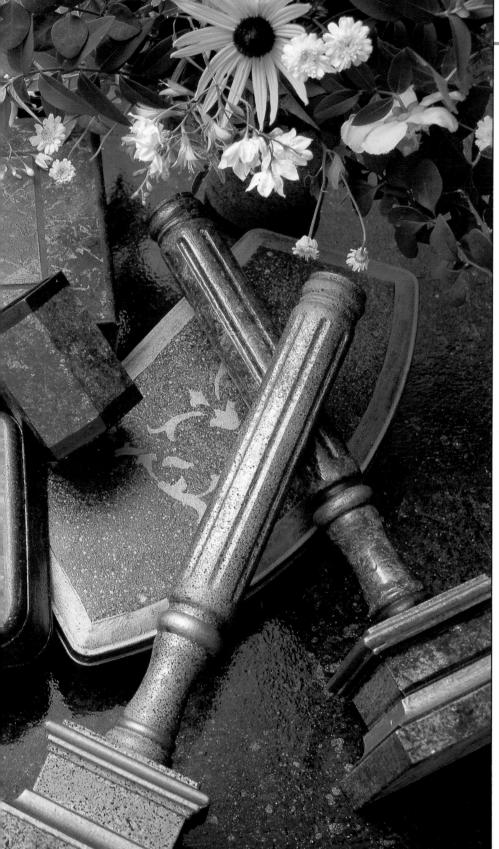

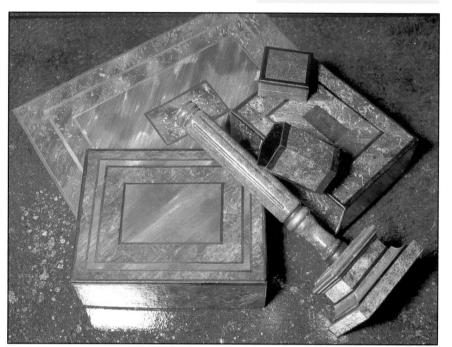

ABOVE: The tortoiseshell paint technique worked in different ways gives a whole range of possible effects.

ABOVE: The tortoiseshell effect (see page 34) painted here has been enhanced using gold paint.

ABOVE: Here a grained wood panelled effect has been created using wood colours like burnt sienna and burnt umber.

FRAMES

he illustrations here show how varied and effective the different paint techniques can be when applied to picture or mirror frames.

Use these ideas to create an original and amazing display for your favourite pictures and mirrors. Choose inexpensive frames, and then transform them into attractive and stylish pieces.

A comprehensive range of paint techniques has been used here, in an amazing variety of colours, offering a inspiration for your own experimentation.

RIGHT: The weight of the tortoiseshell effect on the mirror is balanced by applying the same technique below the dado rail.

BELOW: Inexpensive frames have been spattered using green, gold, brown and black paint, and set off the delicate pictures perfectly.

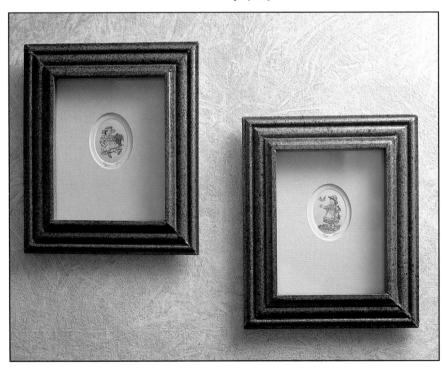

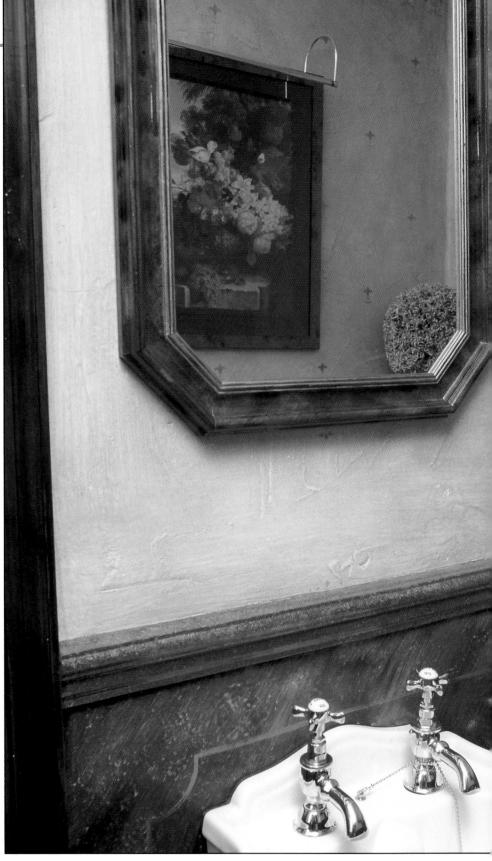

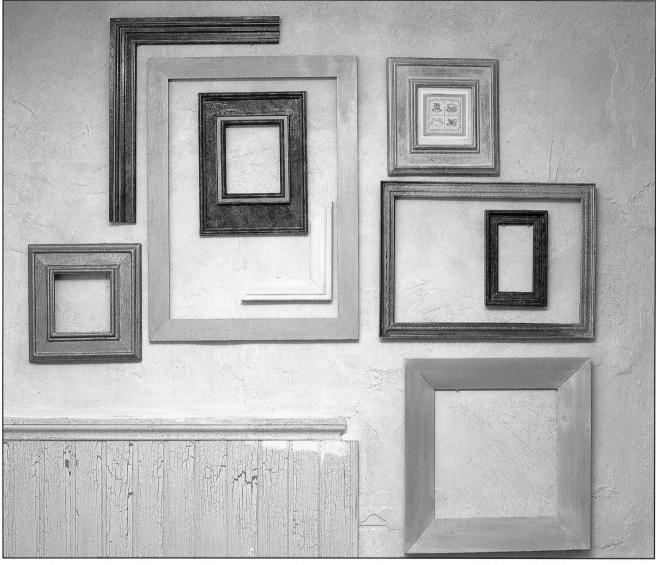

'ANTIQUE' MAHOGANY CHESS BOARD

ake the most of old and unused items around the home, especially when you first start playing with paint techniques. Here, an old tool box, which was found at the back of a garage, has been given a totally new lease of life.

Firstly, the box was painted with a mahogany paint finish, and then a chess grid was added to its top surface. The interior of the box now holds the chess pieces. The same technique could also be applied to an old table.

1 Coat the surface with an oil-based salmon-pink paint. Mark out the pattern using the diagram. At this stage ignore the striped effect around the edges.

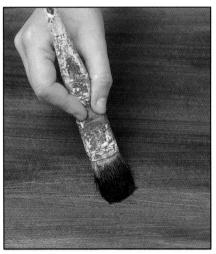

2 The two predominant colours are burnt sienna and burnt umber. Mix in a little oil-based varnish into the colours, then brush them on to the surface carefully.

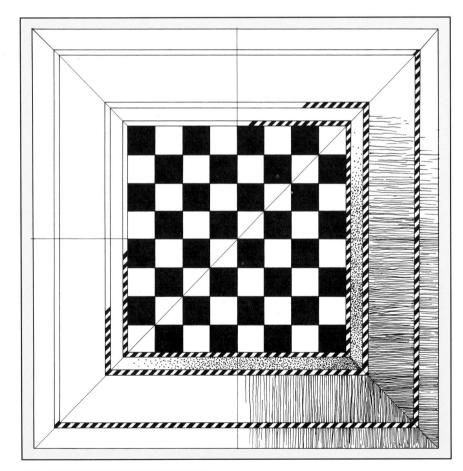

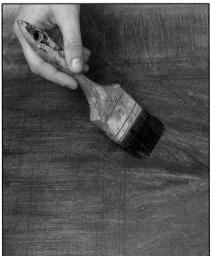

3 Drag a small brush through the glaze to give a grained effect. Soften using a soft pasting brush, thus giving the illusion of depth.

LEFT: The chessboard. If necessary this diagram can be blown up on a photocopier to fit the size of table you are going to work, alternatively simply enlarge the design as you mark it out.

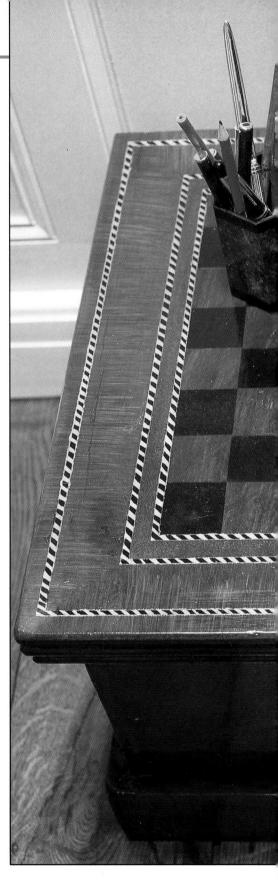

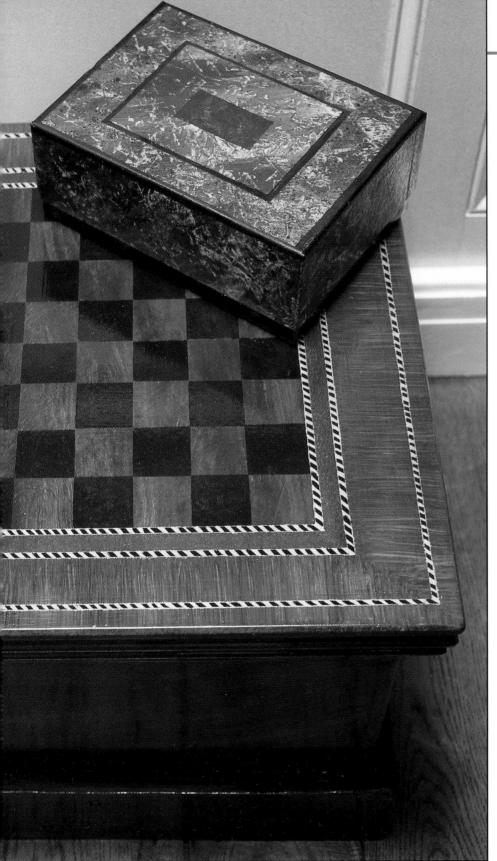

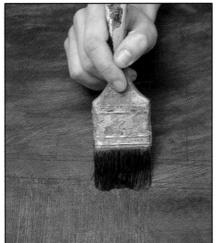

4 Leave the effect you have created in the chessboard square, but using the same brush drag the glaze in the outside area outwards.

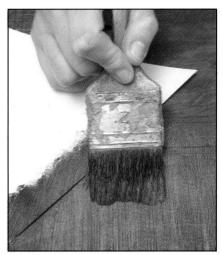

5 To achieve the mitred corner use a piece of card across the corner you are painting.

6 Carefully stipple the area between the edge and the chessboard using a small stippling brush. Leave the surface to dry.

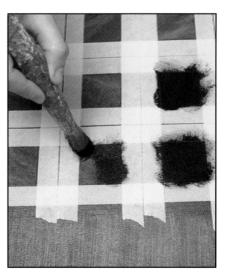

Now work on the chessboard itself.
Using a low-tack masking tape, mask
off the areas around the squares and fill in
the areas with black paint.

LEFT: Although the design has been painted on to the wooden box top here, you may prefer to paint it on a flat board. This would make the chess set easier to move.

The main aim of this piece of work was to create an individual item, not to recreate photographically a mahogany finish (although to create the mahogany finish a piece of wood was used for design guidance).

The trick is to try and emulate the general characteristics of the mahogany wood, and give the box a new purpose by adding a chessboard.

Although mahogany wood was used as the background for this chess set, you may prefer to work the design over a different paint finish. Ragging or dragging could work well, but it would be better to avoid a busy effect, which could detract from the design.

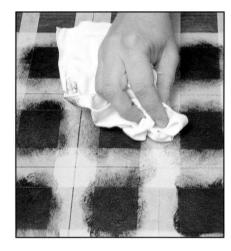

8 Rag off the excess black paint to reveal some of the graining underneath.

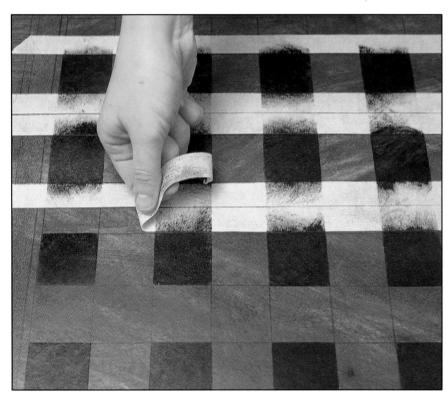

9 Before the paint has completely dried, gently remove the masking tape and repeat filling in the remaining squares.

RIGHT: When the box is not in use for playing chess it can be used as a small side or coffee table.

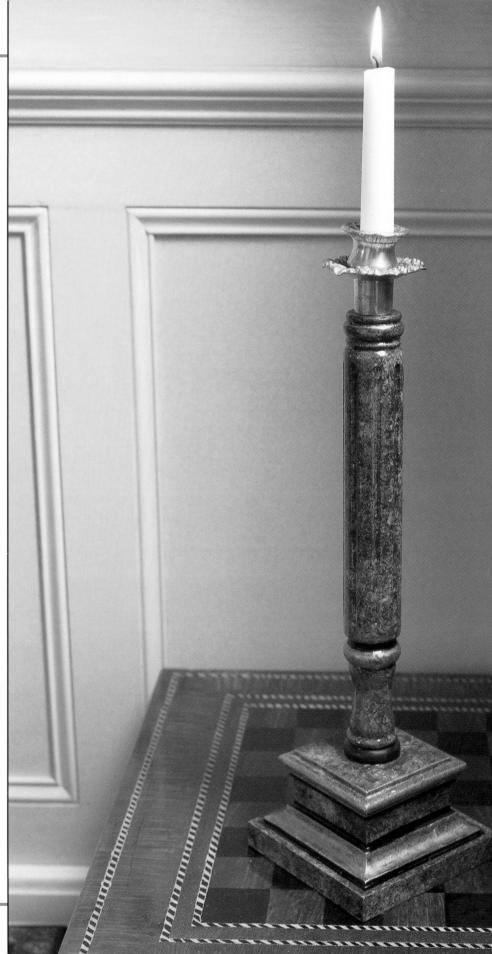

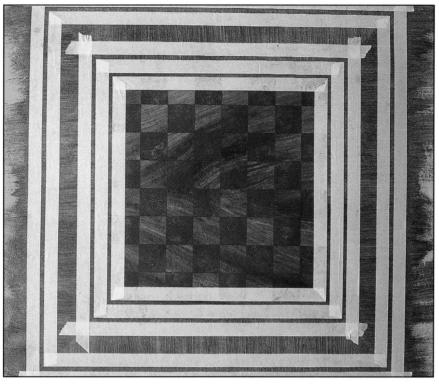

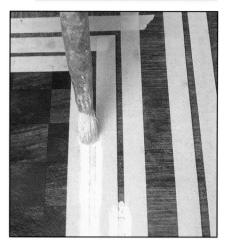

11 Paint these lines with a dirty-looking off-white paint and leave to dry.

10 Once all the black paint has dried, mask off the lines which frame each differently painted section. Mark off lines of about 5mm (1/4in) all round.

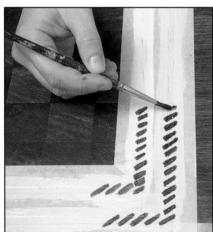

12 Use a small brush to paint on diagonal black lines, then carefully remove the masking tape and leave the paint to dry.

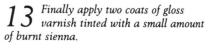

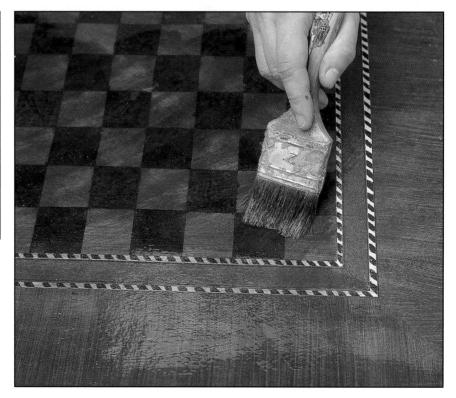

STRIPED BATHROOM

ne of the most simple ways of creating a very dramatic effect is to use just two colours and create a striped effect. The stripes themselves can be of different thicknesses, say a darker colour in thin stripes and a lighter colour with thicker stripes. The stripes are so easy to create because they are simply strips of masking tape, so varying the thickness is easy.

To make this effect even more interesting, why not use the same colour and just alter the tone? This is exactly the effect achieved here. Subtle stripes in two different shades of green add interest to this small but ornate bathroom.

Here, the simple but clever effect has been enhanced with stylish accessories. This is a technique, which looks dramatic once finished, but is quick to create.

2 Using a low-tack masking tape, mask off stripes varying the width if you wish. Here we have used the width of the masking tape as the stripe width.

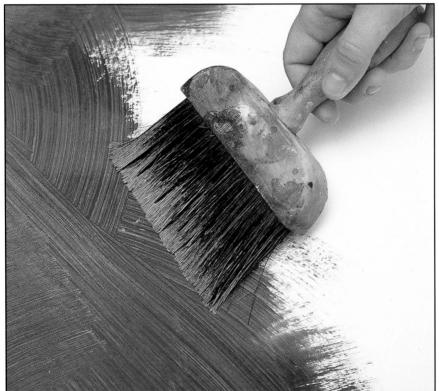

1 Paint a coloured, thinned eggshell glaze on to an oil-based surface, (see page 16) then leave to dry. Green was used here, but any colour can work well.

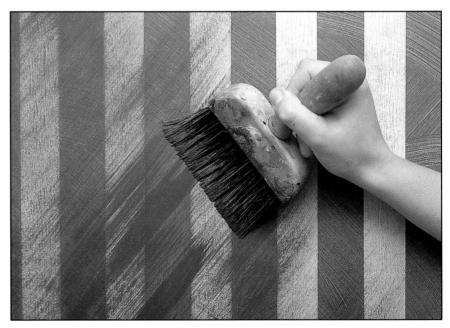

3 Paint a slightly darker, unthinned coat over the unmasked areas.

LEFT: This paint effect has been used in the whole room here, but would work equally well used in a panel in a larger room.

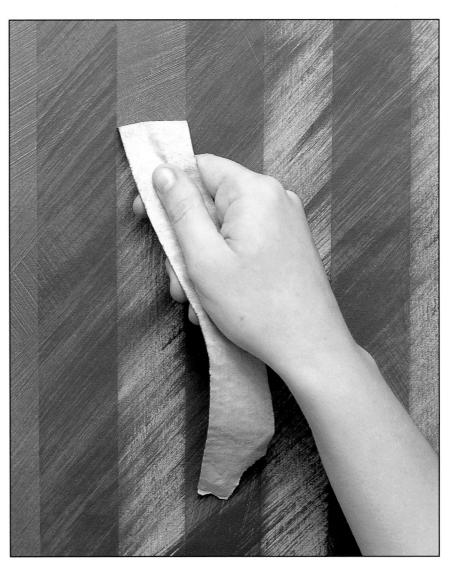

4 Before the paint is completely dry remove the masking tape.

CHILDREN'S ROOMS

or an effective look in a child's bedroom, it is best to take a theme and work around it, even to the extent of painting boxes, cupboards and furniture using the same design. However, when working on children's rooms ensure you use a theme which can grow with the child, unless you intend changing the scheme regularly.

The rooms here have been inspired by various stories from books and age old, traditional and popular themes. You can also get ideas and inspiration from children's wallpaper or fabric designs.

RIGHT: Give interest to a plain wall by painting a simple roller blind on to a sponged background.

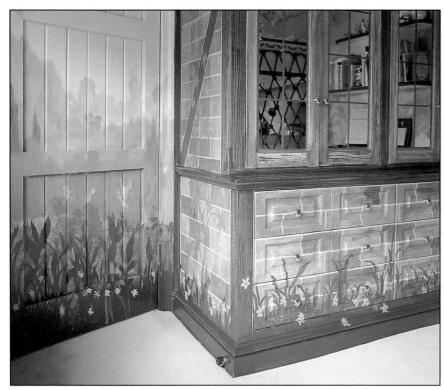

ABOVE: The wardrobe unit has been transformed into a rustic oak-beamed cottage with foliage around the base.

RIGHT: The whole room has been treated using simple paint techniques, and gives the overall impression of an overgrown garden.

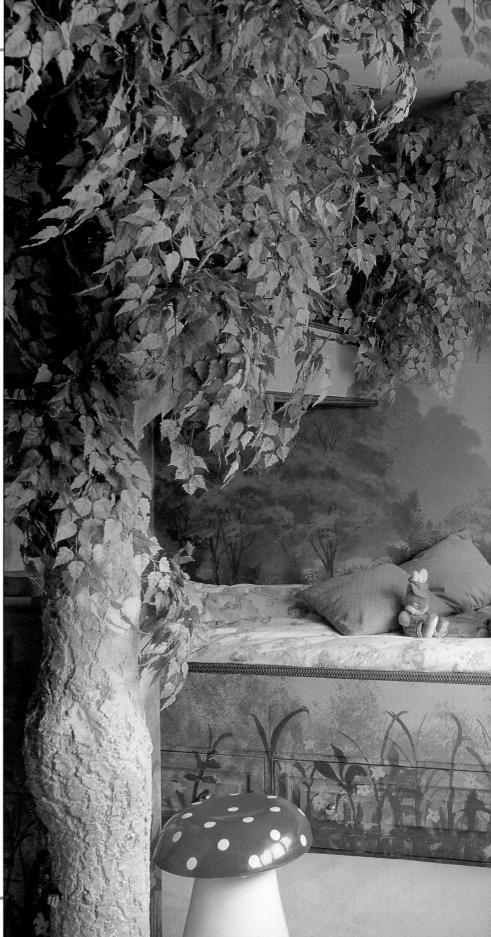

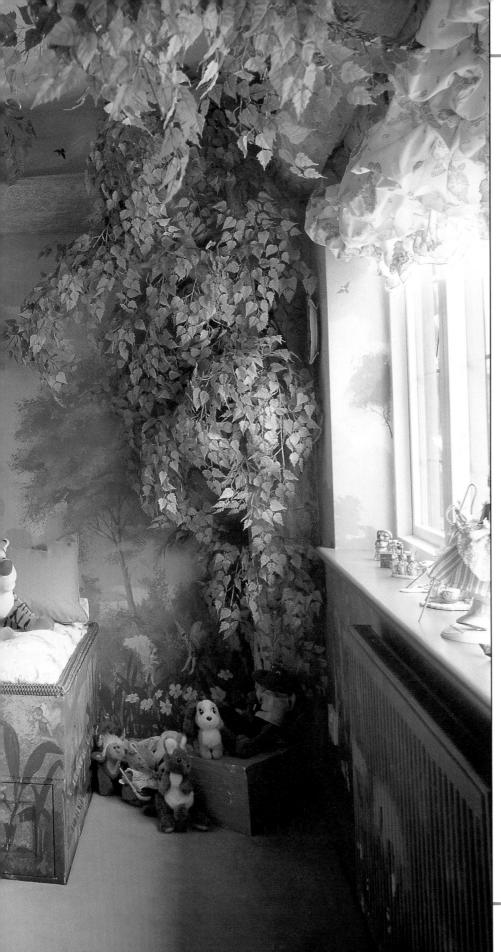

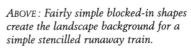

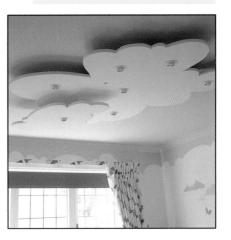

ABOVE: A cloud shape cut from MDF (medium density fibreboard) echoes the clouds painted on the walls.

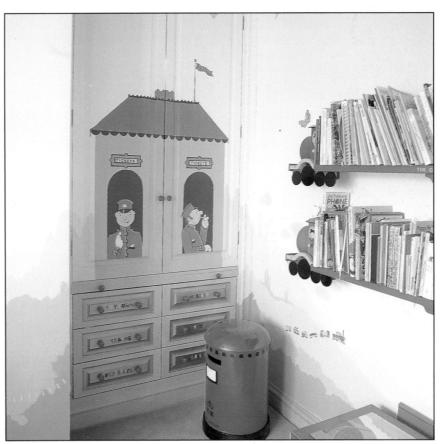

ABOVE: A simple mural transforms an ordinary built-in wardrobe and drawers.

DUCK BEDROOM

Paint the wall in a bright sunny yellow water-based emulsion paint. Using the duck templates given on page 107 make a couple of stencils in two different sizes, small and medium.

Use these stencils to decorate the walls with painted ducks, following the instructions below. The theme was taken a stage further in this bedroom as the duck shape has also been used to make the duck headboard, which has been cut out from MDF (medium density fibreboard) then painted.

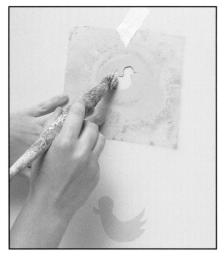

1 Stencil the medium-sized duck around the room (see page 107). Colour the body in. Then make a smaller stencil, and paint the smaller duck in the spaces.

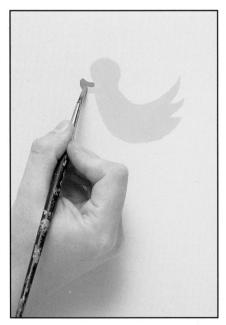

2 Using a much smaller paint brush fill in the beaks and eyes on all the ducks.

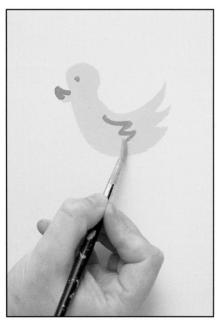

3 Using the small brush fill in the wings, working freehand.

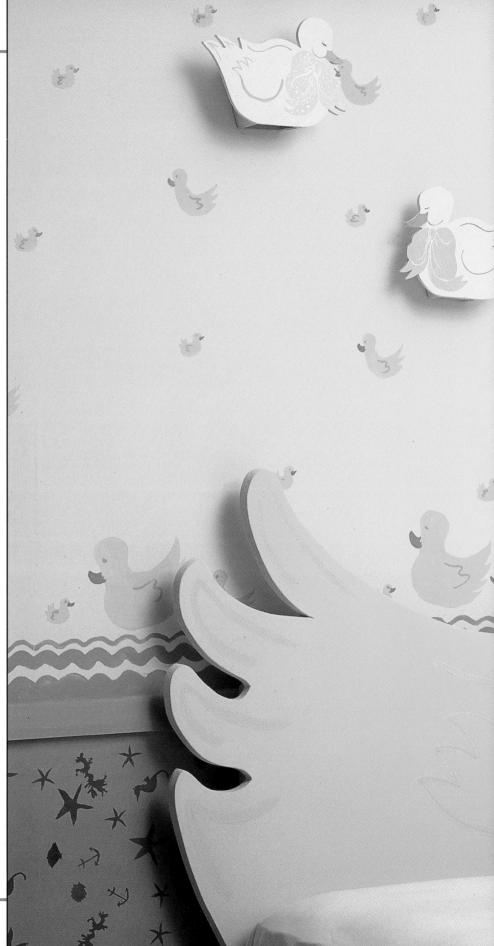

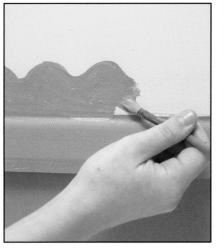

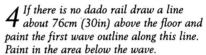

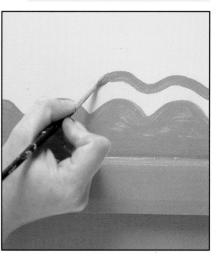

5 Now paint further waves freehand with a small paintbrush, or use the stencil given on page 107.

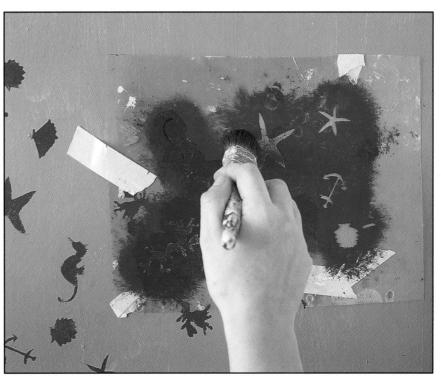

LEFT: The inspiration behind this stencilled bedroom came from a discontinued wallpaper, and the design has been taken a stage further with the addition of smaller ducks.

6 Draw and cut out various nautical shapes such as shells, seahorses and shellfish from acetate or card, and stencil them in a dark blue or gold in the painted section below the waves.

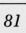

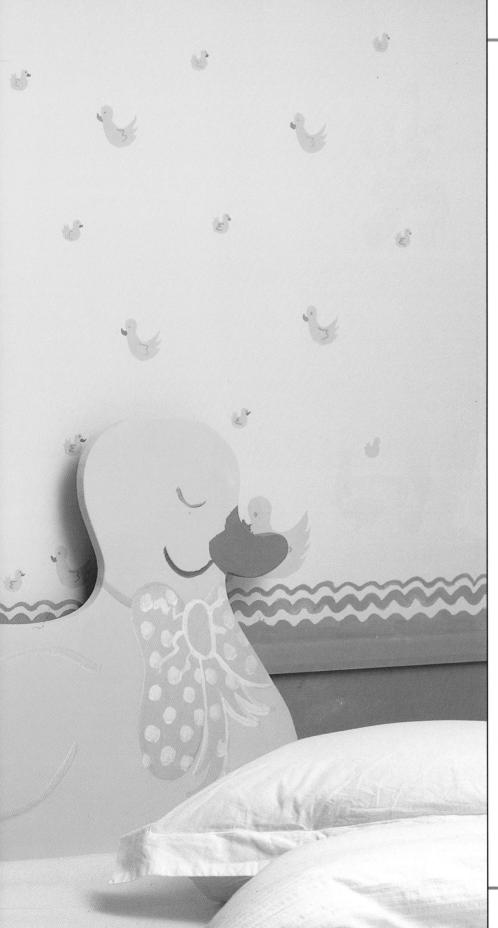

CAROUSEL

his is another good theme for a child's room, and again is it fairly quick and easy to create. Although the finished effect may look rather complicated, it is simply a matter of taking each step at a time.

After the tented effect has been painted use the stencils given on page 106 to fill in the design with horses. The room can be painted with water-based emulsion paints.

Firstly tack a long piece of string to the centre of the ceiling, and using this as a guide, draw lines to the four corners of the room. Then draw lines to the middle point between the ceiling and the wall, and break each section up twice more. Now create the inner circle. Tie a pencil about 50cm (20in) from the centre and using this as a compass, draw the inner circle. Working around the inner circle and following the lines already drawn, draw in two scalloped shapes in the inner circle.

Work the outer scallops. Using a pencil and a ruler, follow the drawn lines down the walls for about 60cm (24in) and use a large plate to draw in the scalloped edges. Lastly draw in the final scallops under the tented area freehand.

Once all the areas are drawn in the tented area can be painted. Choose colours to suit the scheme for the room.

1 Draw straight lines down from the tented ceiling, stopping them at different heights. Then stick the rope stencil (page 106) at the end of one of these lines.

2 Stencil the first colour of the rope, using the pencil lines as a guide. Leave the paint to dry.

3 Add interest to the rope section by stencilling a second and even a third colour to the rope.

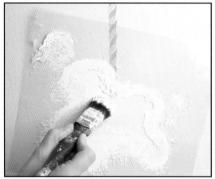

4 Position the horse stencil given on page 106 at the end of one rope section.

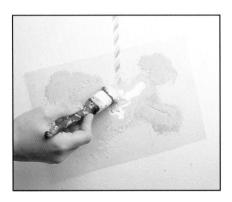

5 Fill in the main body of the horse using one colour of paint, and leave to dry.

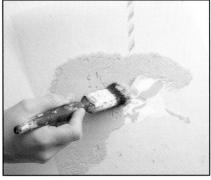

6 Fill in the details using different colours of paint. When you are working this design it is important to wait for the paint to dry before adding a second colour.

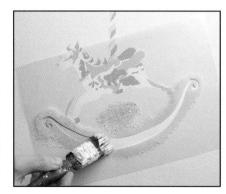

Repeat the process for all the other lengths of rope.

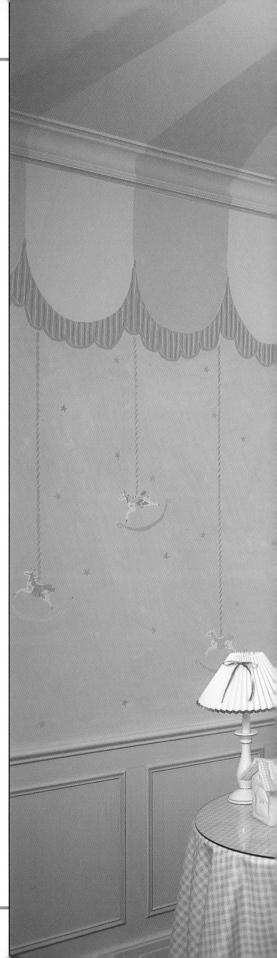

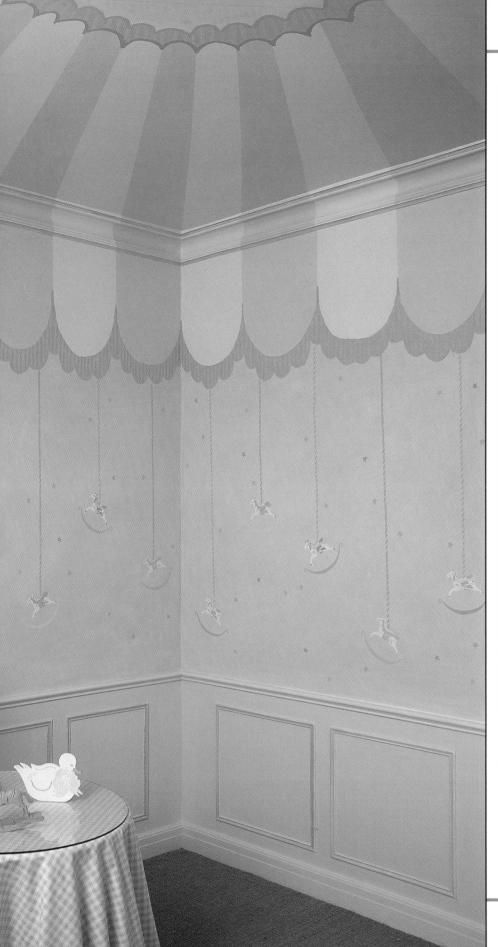

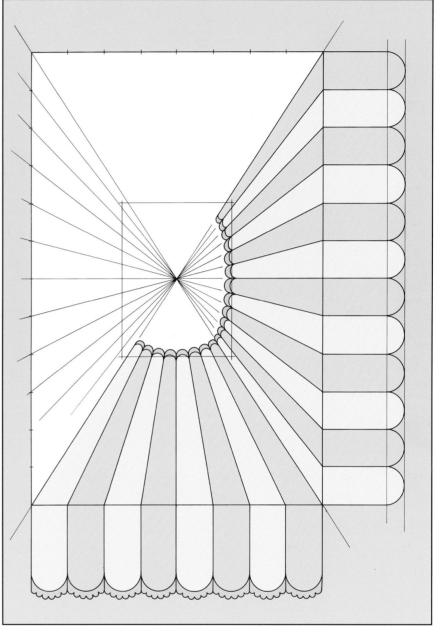

LEFT: Dancing horses add real movement to this child's bedroom. It is just the room most children would love to own. The overall effect has been enhanced with a toy rocking horse placed on the bedside table.

ABOVE: The tented ceiling design, which could be painted in a range of colours. Here pastels are used.

Projects

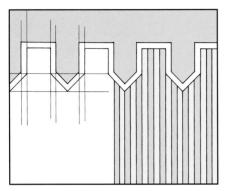

ABOVE and BELOW: The diagrams offer different alternative edgings to the tented ceiling, both of which are fairly easy to follow.

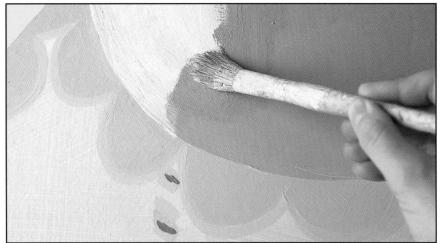

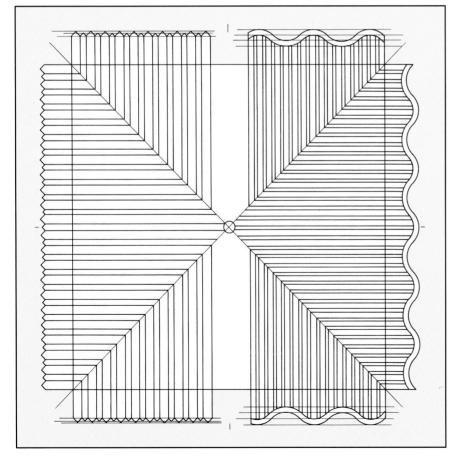

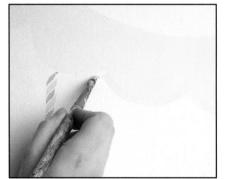

2 Pick out areas of detail using a much smaller, finer brush.

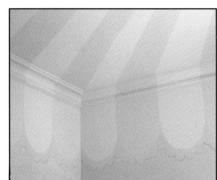

3 This is the finished tented effect before the ropes are stencilled.

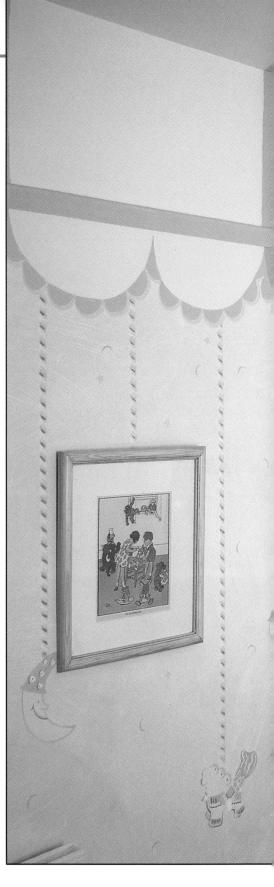

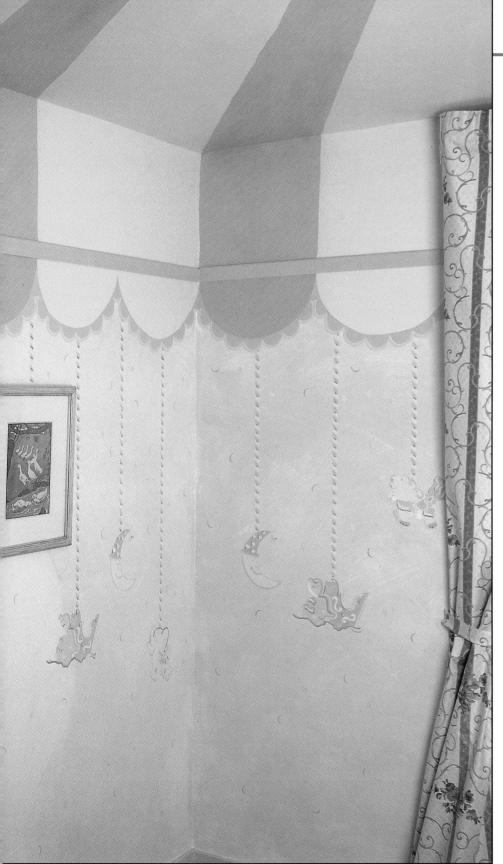

LEFT: The carousel painted here is worked in exactly the same way as the one on the previous page, but different colours and motifs have been used.

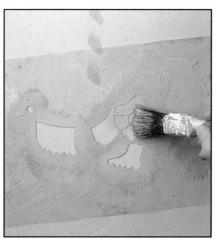

ABOVE: Position the stencil with spray adhesive, then paint in the designs letting each colour dry before adding the next.

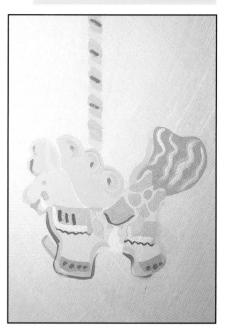

ABOVE: The inspiration behind these animals was taken from a wallpaper border and then transferred to stencils.

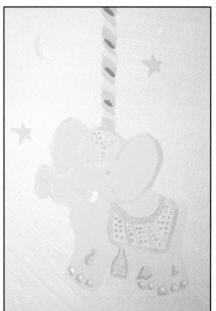

ABOVE: A cute and colourful motif works well like the little elephant design which has been used here.

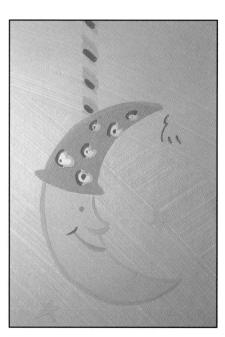

ABOVE: The man in the moon, a particularly simple and effective design motif.

HANDPAINTED CANVAS FLOORCLOTH

anvas floorcloths were traditionally found in eighteenth-century country homes. They are generally made from heavy duty cotton duck canvas, and then are primed with many coats of paint and varnish. These floorcloths were very hard wearing and made an easy-to-clean and care for alternative to an ordinary carpet or traditional rag rug. Because they were well primed they were often used in areas like bathrooms or kitchens where their water resistant qualities were useful.

In addition, a hand-painted floorcloth can be totally unique if you create a new design or choose a different colour theme for yourself.

Firstly you will need to buy a reasonably heavy duty cotton duck canvas, which can be purchased from a good artists' supplier or sailmaker.

The finished floorcloth could also be used as a wallhanging.

ABOVE: A selection of pastel shades which have been used in creating this pattern.

1 Make a frame to the required size for your floorcloth using 5 x 2.5cm (2 x 1in) softwood. Alternatively work on a large flat surface or table.

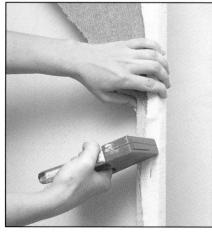

2 Using the frame stretch the canvas from the centre pulling alternate sides as you work and working towards the corners until the canvas is reasonably taut all round.

Prime the canvas with a coat of waterbased emulsion paint thinned with 40 per cent water, and leave to dry. Apply another two coats of unthinned paint.

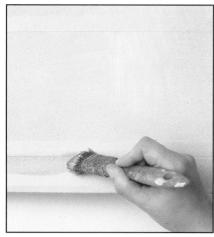

4 Carefully mask off the two thin borderlines one 2.5cm (1in) and the other 25cm (10in) from the edge. Paint both these lines.

RIGHT: This handpainted floorcloth works particularly well on the old oak floor depicted here, but would also look good on a plain coloured carpet.

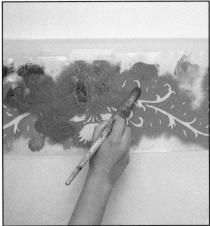

5 Then, using the trailing flowers template on page 105, make a stencil from thin acetate. Position the stencil with spray adhesive at one end of the rug. Paint in the green leaf areas.

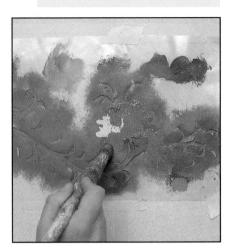

6 Use strong primary colours to pick out the floral shapes by working a stippling action with the brush over the stencil.

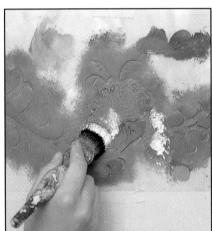

Z Stipple small highlights using white paint. Move the stencil to the opposite end of the rug and repeat the process.

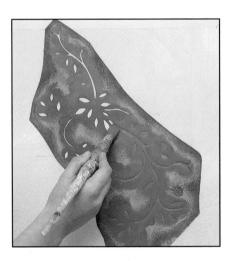

Our the main rug templates on pages 103 and 105, make a second stencil from thin acetate and use this to stencil leaves over the entire central panel.

Projects

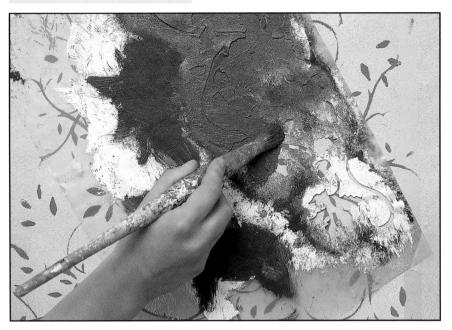

9 Add interest to the central area by using different shades of green while you are stencilling.

RIGHT: The finished rug should be protected with several coats of clear or tinted oil based varnish.

10 Mask off a framed border around the outside edge of the leaves and fill this in using a contrasting colour.

11 Make up the corner stencil using the template given on page 102. Then paint in the corner borders with this stencil.

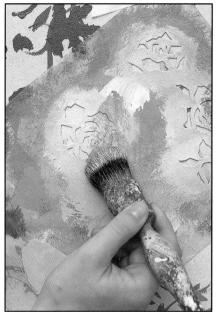

12 Stencil in various flower shapes using primary colours. Make these fairly random, and step back to see where these sharp areas of colour should be added.

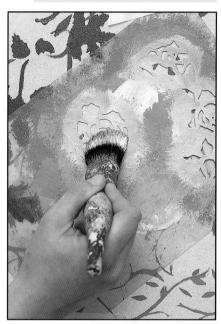

13 Using white or a little raw umber, alter the primary colours and stencil a few more in these different shades.

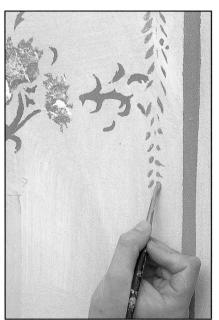

14 Add a further border all round the edge of the rug using a freehand motif and a small artists' brush.

15 Leave the rug to dry completely.
Once dry remove the rug from the frame. Turn under a 2.5cm (1in) edge to the back of the rug and glue back on itself.

STENCIL MOTIFS

tencilling is a fairly cheap and very versatile method of enhancing any surface, and there are many simple and effective ways to alter the stencilled image to improve the overall effect.

Shop-bought stencils are fine, but for more personal images and creative looks, use different and unusual images.

Paintings by renaissance artists like Mantegna (1431 – 1506) are a wonderful source of inspiration for borders and motifs when stencilling. Look at books in your local library for ideas.

Almost any image from a fabric, a book or a piece of china can be used as inspiration and source material for stencilling. Find the image you like and copy it on to tracing paper, or photocopy and enlarge or reduce the image to the required size. Transfer this image on to stencil card or acetate film and cut around the image using a craft knife, remembering to leave any bridging pieces intact so that the image will hold together.

It is best to spray the back of your stencil with spray adhesive, which can be bought from most art shops. This low-tack spray allows you to stick the stencil to the wall or object, leaving both hands free to paint. It also helps to prevent the paint from bleeding under the edges, avoiding any fuzzy shapes. Because the spray glue is low-tack the stencil can be easily moved.

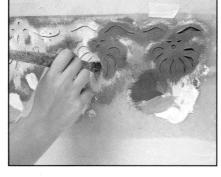

1 Spray the back of the stencil, position it carefully, then stipple the first colour using a fairly stiff brush and water-based paints.

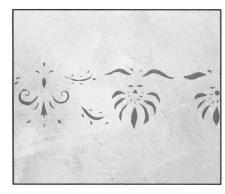

2 Remove the stencil to reveal a sharp image and leave to dry.

Reposition the same stencil over the image, but move it slightly to one side and stencil again with an off-white paint.

4 Remove the stencil to reveal a more three-dimensional effect and leave to dry.

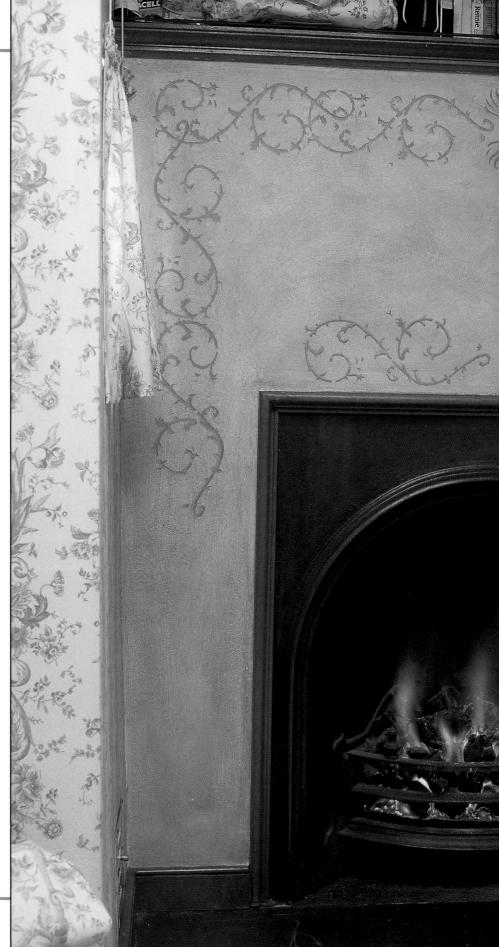

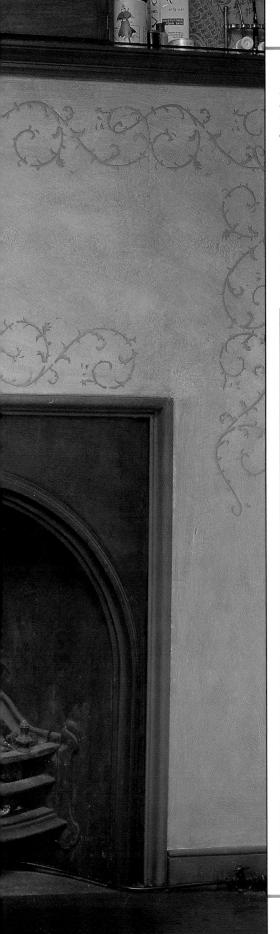

LEFT: The stencil design used to enhance and embellish this Victorian fireplace. The design was inspired by a detail on a painting by Andrea Mantegna.

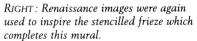

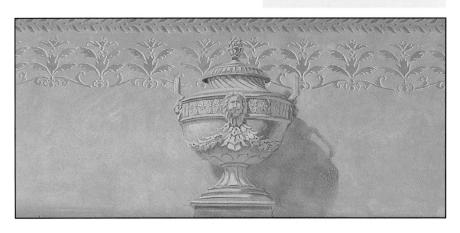

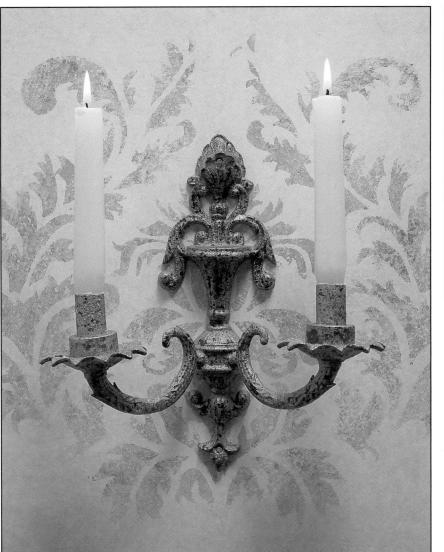

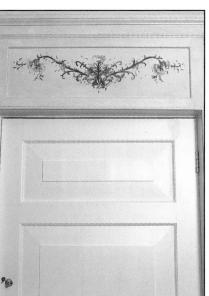

ABOVE: The image used here was influenced by the design on the fabrics found in the room, which enhances the overall effect.

LEFT: The candle sconce here neatly echoes the damask stencil which has been used on the next page.

DAMASK ROOM

The wonderful stencil designs in this room were inspired by an expensive Warners fabric which has been used for the curtains. Although this project looks sumptuous, and somewhat ambitious, it is not too difficult to realise. The effect works particularly well in this room with its high ceiling and deep cornice.

Here the image was easily translated from the fabric. However, if you can't find an image you want to use as a stencil, you could use one of the ones provided at the back of the book.

1 Thin a water-based paint with about 50 per cent water and apply this over the background area.

Rag or distress the area with a rag or a dry brush to create a soft background as the base for your stencil. Leave to dry.

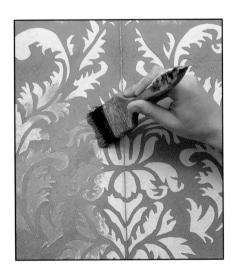

3 Use a plumbline (a weight tied to a piece of string will do the trick) to position the stencil on the wall. Stencil the main colour using a water-based emulsion.

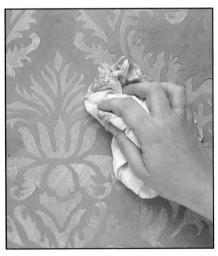

4 Use a soft rag to remove any excess paint and distress the image slightly.

5 Sponge the darker colour at random to break up the image a little, then remove the stencil.

RIGHT: This is a good example of how sophisticated stencilling can look when used with the right image, in appropriate surroundings.

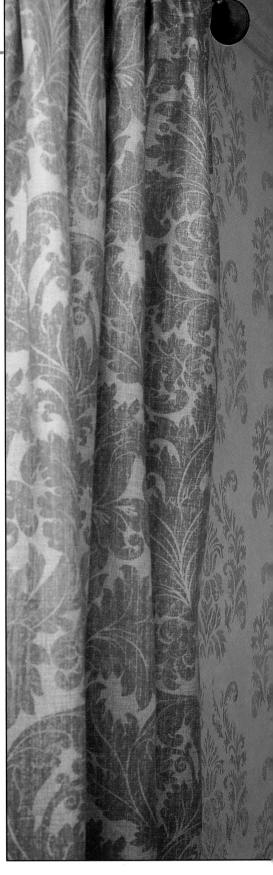

Projects

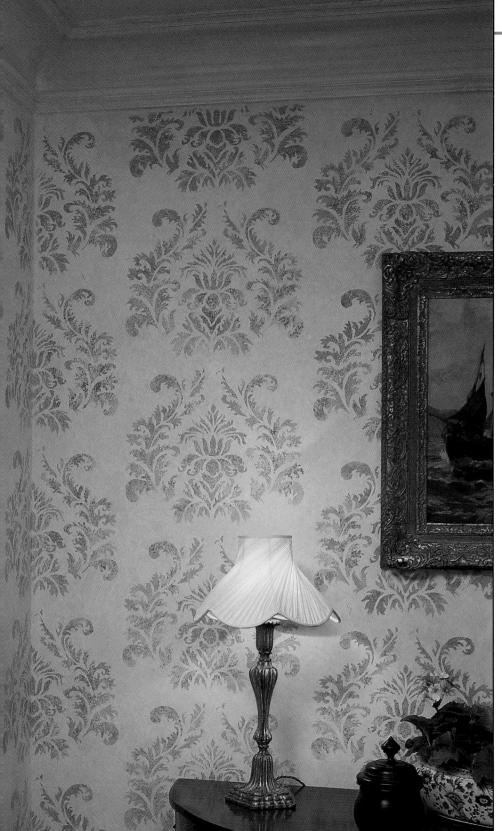

6 Once the image is dry, enhance the distressed look by rubbing the paint lightly with a fine grade sandpaper.

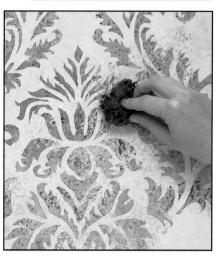

Z Sponge an off-white emulsion paint over the stencil to soften the image.

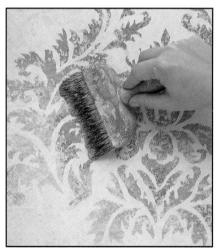

Apply a milky wash, made up with offwhite emulsion and about 70 per cent water, over the whole area and distress with a dry brush.

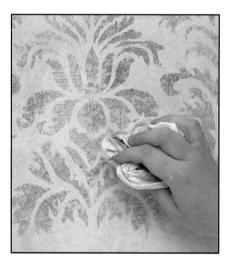

Ocarefully rub off patches of the milky wash to expose some sharper areas of the stencil.

LEFT: The main paint colours which were used in this room.

STENCILLED SCREEN

A screen or room divider can easily be made to any size using pre-cut MDF (medium density fibreboard) boards, which are then hinged together. Most timber merchants will cut fibreboards to the required size.

If you wish to individualise the screen why not try shaping the top with a domed or rounded shape, or even design a castle or crenellated shape?

The stencils used here have been given on pages 102 and 104, but you could

create your own design using different stencils, either shop bought, or hand-made ones. If you do create your own design, try it out on a piece of card before painting the screen itself. Your final design, or the design used here could also be applied to a panel or a door in the home.

Before you start to work on the screen you need to prepare it. Coat the fibreboard with a proprietary wood primer then apply two coats of oil-based white eggshell.

1 On a colour washed background, mask off the corner and border areas.

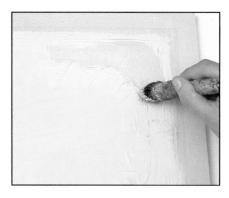

2 Stipple on the first colour between the masked off areas.

3 Carefully remove the masking tape.

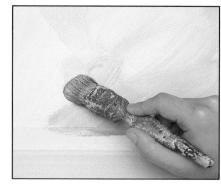

4 Mask off the middle panels and apply a water-based emulsion thinned with 40 per cent water.

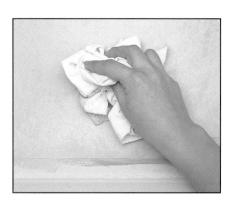

5 Rag inside this panel to create a cloudy effect. Leave to dry.

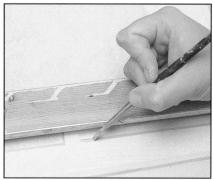

6 Using a fine brush, paint grey lines around the border and corner shapes.

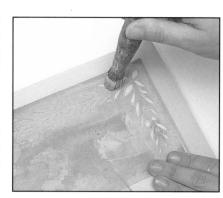

7 Use the template on page 102 to make a stencil for the corner design. Stencil the corner designs.

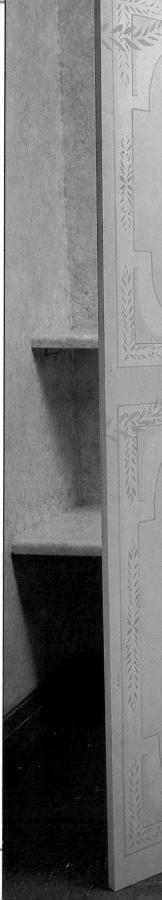

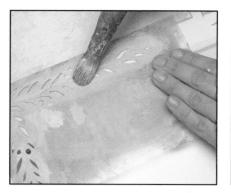

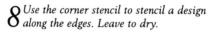

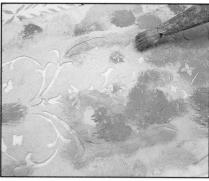

Ouse the template on page 104 to make the central design, and position the stencil.

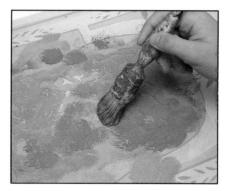

10 Using a small brush, stipple different colours on to the stencil, blending areas to add interest.

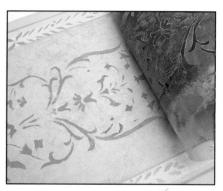

1 1 Carefully remove the stencil to reveal the central design underneath.

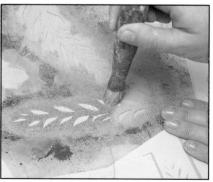

LEFT: Once you are happy with the design make the screen more sturdy by painting it with two layers of oil-based varnish.

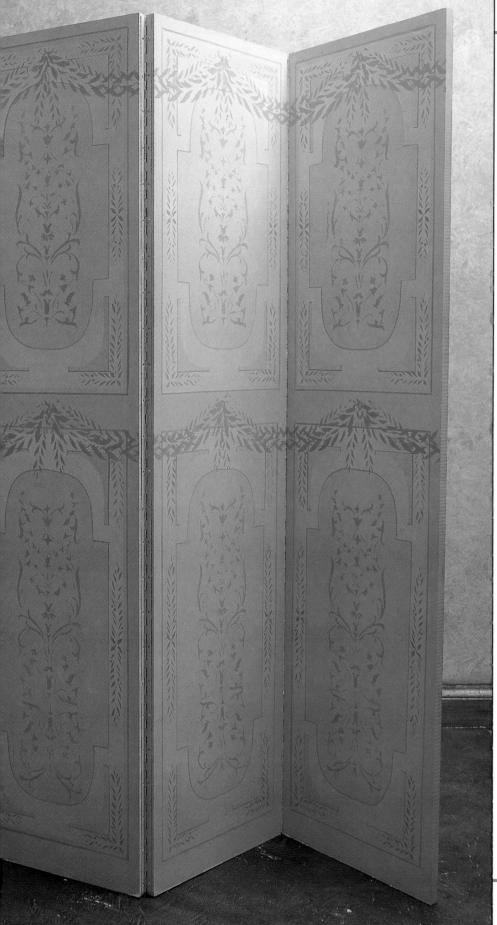

SCREEN REVERSE

The effect created on the reverse of this screen uses the central stencil from the previous screen seen on pages 94–95, but has a totally different look. This is due to the fact that more dramatic bolder colours have been used. Again the effect could be created on a door or panel if you prefer.

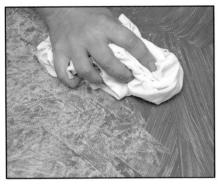

1 Apply a glaze and rag the whole area to create an interesting working background.

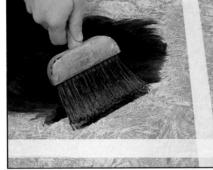

2 Using a low-tack masking tape, mask off a panel 5cm (2in) from the edge and apply a wash of artists' oil-based Prussian blue mixed with a little oil-based varnish.

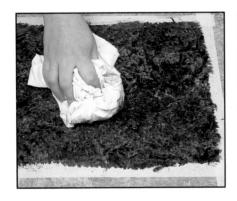

3 Using a very soft rag, rag this wash to create a soft, cloudy effect.

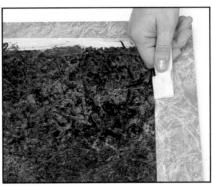

4 Carefully remove the masking tape to show a straight edge, and leave the screen to dry.

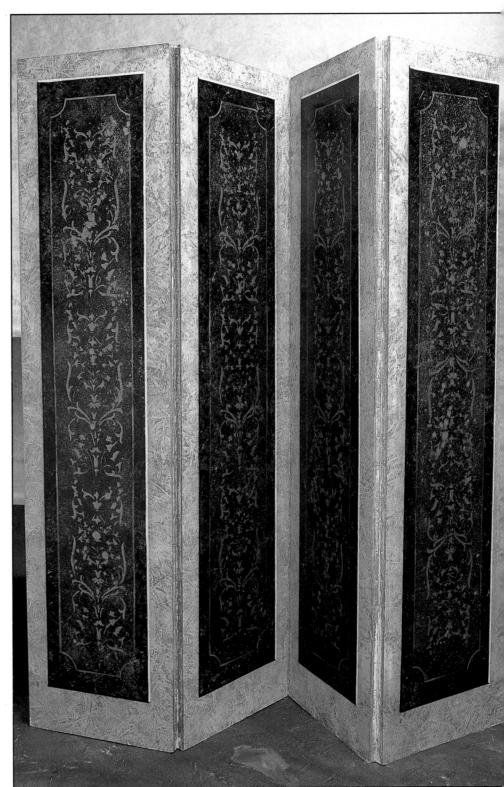

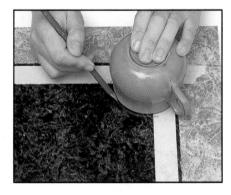

5 Using a low-tack masking tape, mask off an area 5cm (2in) inside the blue panel, and use a cup to draw in the quarter circles in the corners.

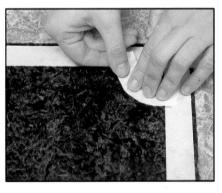

6 Using a low-tack masking tape, mask off these quarter circles.

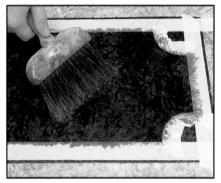

7 Apply a clear varnish mixed with a little white spirit in the masked off area.

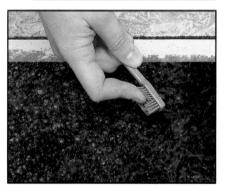

8 While the varnish is still wet, use a toothbrush to spatter gold paint mixed with a little white spirit on to the surface. Leave the screen to dry.

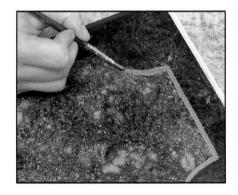

9 Contain this panel by painting a fine gold line around the edge, using a fine

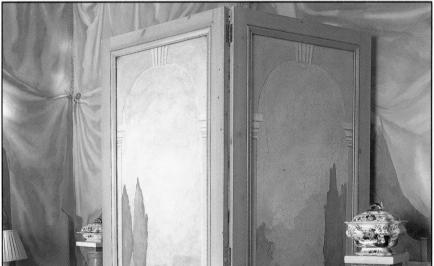

artists' paintbrush.

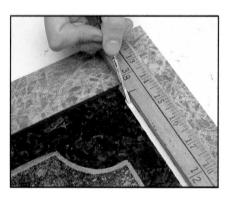

10 Use a ruler and a fine paintbrush to paint a fine white line around around the outside edge.

LEFT: The final screen looks very dramatic. This is really due to the use of much bolder colours in comparison to the previous page.

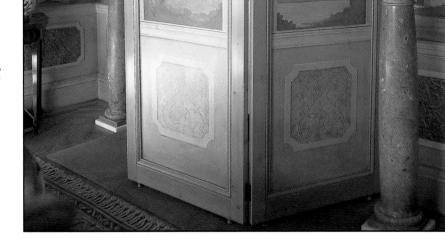

RIGHT: This is a good example of how a hand-painted screen can be used in a sophisticated dining room.

Use the template on page 104 to make up the central stencil. Use this to stencil the design in the centre of the panel, stippling with a gold paint.

BLANKET BOX

he finish created on this box has many different names, but is most often called fossil stone or floating marble. The overall effect is one of random colour created on a flat surface.

Before beginning, experiment with different colours and different media on a flat board. Try spattering on white spirit to see what happens with mixed media.

This finish must be applied to a horizontal surface, or the glaze and white spirit will run.

Make sure the surface is smooth and prepare it with at least two coats of oilbased eggshell. This base colour is important because it will show through.

Experiment by spattering different strengths of colours on to the surface. Finish with two coats of gloss varnish.

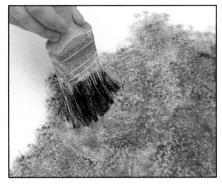

1 Apply a mixture of 50 per cent scumble glaze or oil-based varnish, mixed with 50 per cent white spirit, over the surface. Tint the glaze with artists' oil colour.

BELOW: The blanket box was easy to manoeuvre so that each side could be worked on as a horizontal flat surface.

2 Using a toothbrush spatter the wet surface with the chosen artists' oil colour mixed with a little white spirit. The paint should spread as it lands.

RIGHT: The imitation slate effect is used mainly for presentation purposes, but it can be used as a feature background for special pieces of furniture like the hand-made chair.

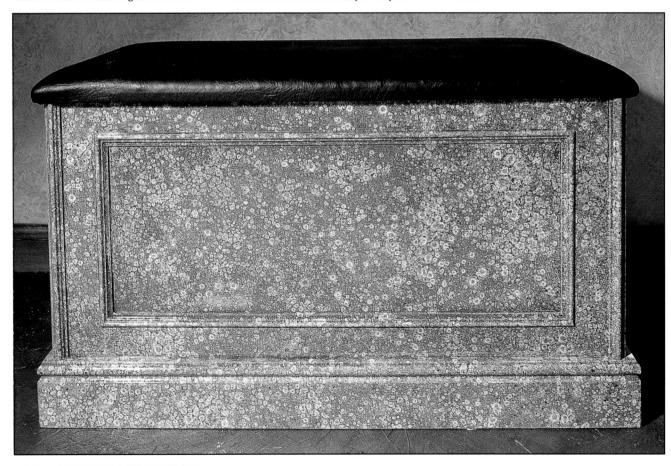

SLATE WALL

his finish should be created on a textured background. If the surface is not sufficiently rough, apply a ready-mixed plaster to the surface with a large piece of wood or a filling knife and create the textured background you want. Leave the surface to dry completely then seal it with water-based emulsion paint thinned with 30 per cent water.

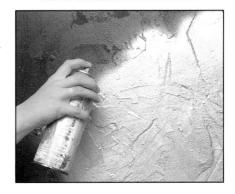

1 Paint or spray the entire surface with silver and leave to dry completely.

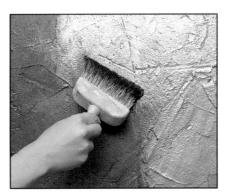

2 Apply a coat of thinned black water-based paint over the whole surface.

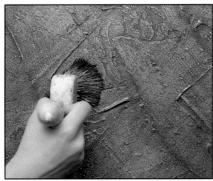

3 Work this into the surface so that it is clear in some areas and darker in others, removing some of the black paint.

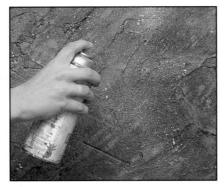

4 Using a silver spray paint lightly spray small sections of the surface silver. Remember to work in a well-ventilated area.

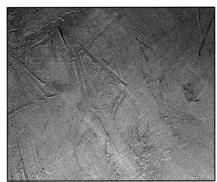

5 This is a close-up of the final finish.

TROMPE L'OEIL PANELLING

hen presented with the main picture, very few people believe that the panels below the dado rail have been created with paint alone. This is, however, the case, and this room offers an extremely good example of how convincing and effective a *trompe l'oeil* panel can be.

Once again one of the tricks which makes the paint effect so convincing is the fact that the dado rail and skirting board have been incorporated in the design.

Before you start to paint, check the dimensions of the panels and scale them up or down to fit the area you are going to be working.

1 Create a highly dragged surface using an oil-based oatmeal eggshell paint. Leave to dry then mark out the panels following the diagram.

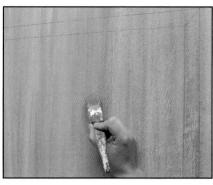

Mix artists' oil colours, raw umber, raw sienna and burnt umber with glaze.

Apply and drag vertically across the areas inside the panels and verticals between.

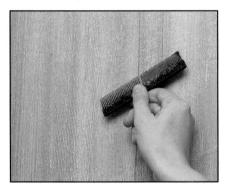

3 Drag and comb down this area to create a random combed effect in some parts of the panel.

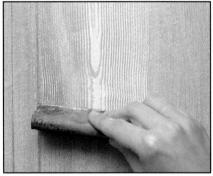

4 Use a heartgrainer to create a heartgrained effect elsewhere in the panel area.

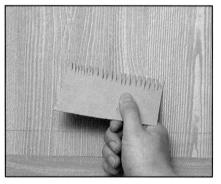

5 Using a homemade comb from stiff card fill in any other areas in the panel.

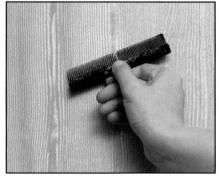

6 Finally, enhance all the effects by lightly dragging the comb over the panel area again.

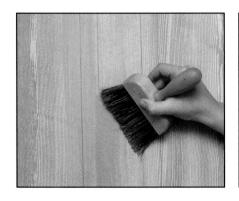

Z Soften the combed and grained effect you have created in some areas with a soft dusting brush worked lightly into the surface.

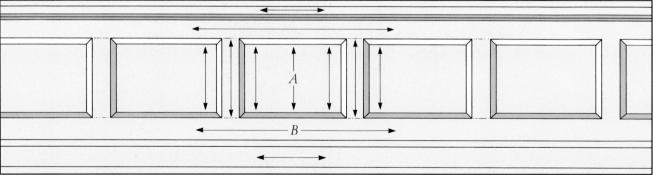

ABOVE: Firstly, work the inner verticals A, then the horozontal areas above and below the panels B.

RIGHT: These panels have been created with the simple use of paint. This is a good way of showing just how effective trompe l'oeil panelling can be.

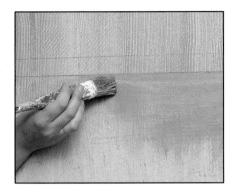

Now work the horizontal areas above and below the panels. Brush the same colour on to this area.

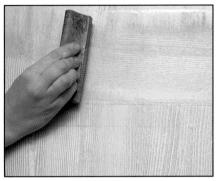

9 Using the comb, heartgrainer and dusting brush, create a wooden effect, but work horizontally. Once you are happy with this, leave the surface to dry.

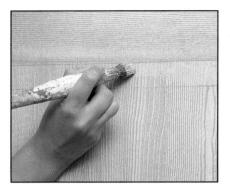

10 Create highlights by painting a thin off-white wash between the previously drawn pencil lines on the top and down one side.

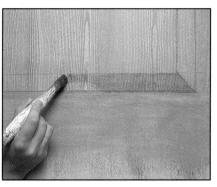

11 Create shadows by painting raw umber mixed with a little varnish between the bottom lines and remaining sides. Leave to dry.

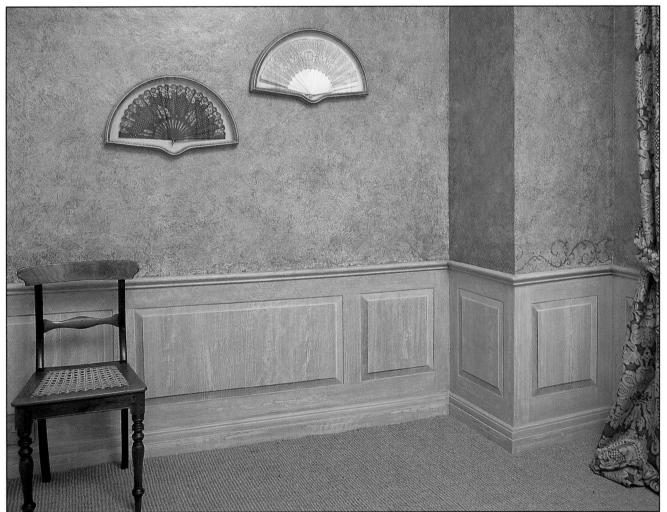

12 Enhance the three-dimensional look further by reinforcing the highlights. Paint small fine lines using a small brush and a ruler.

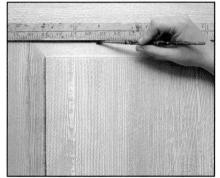

13 Strengthen the shadows by painting a darker line, again with raw umber, along the shadow edge.

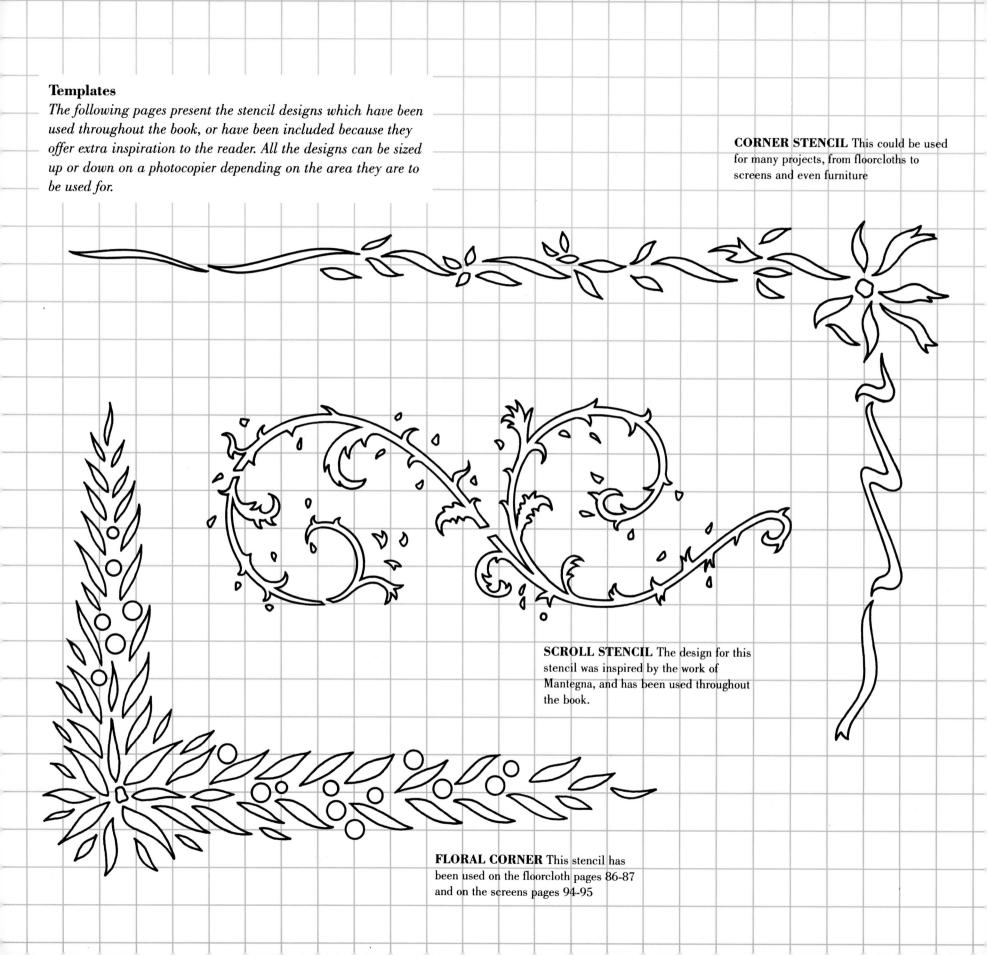

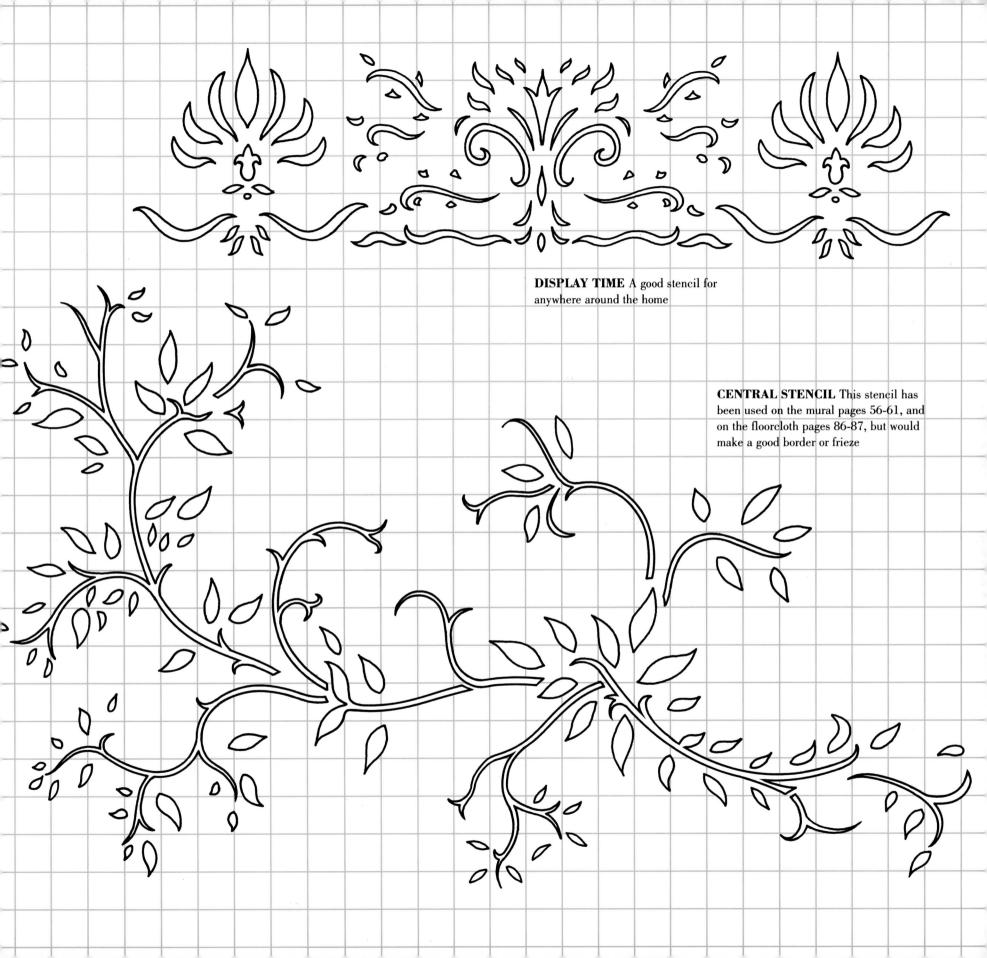

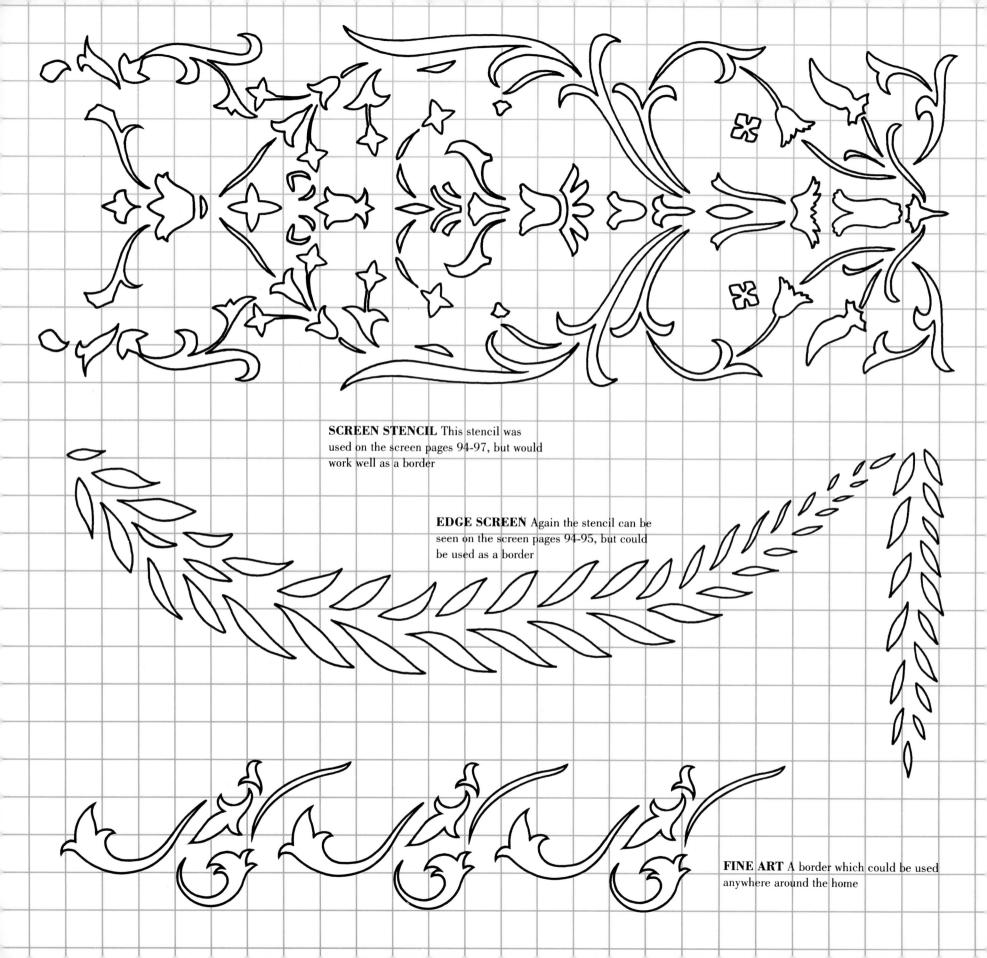

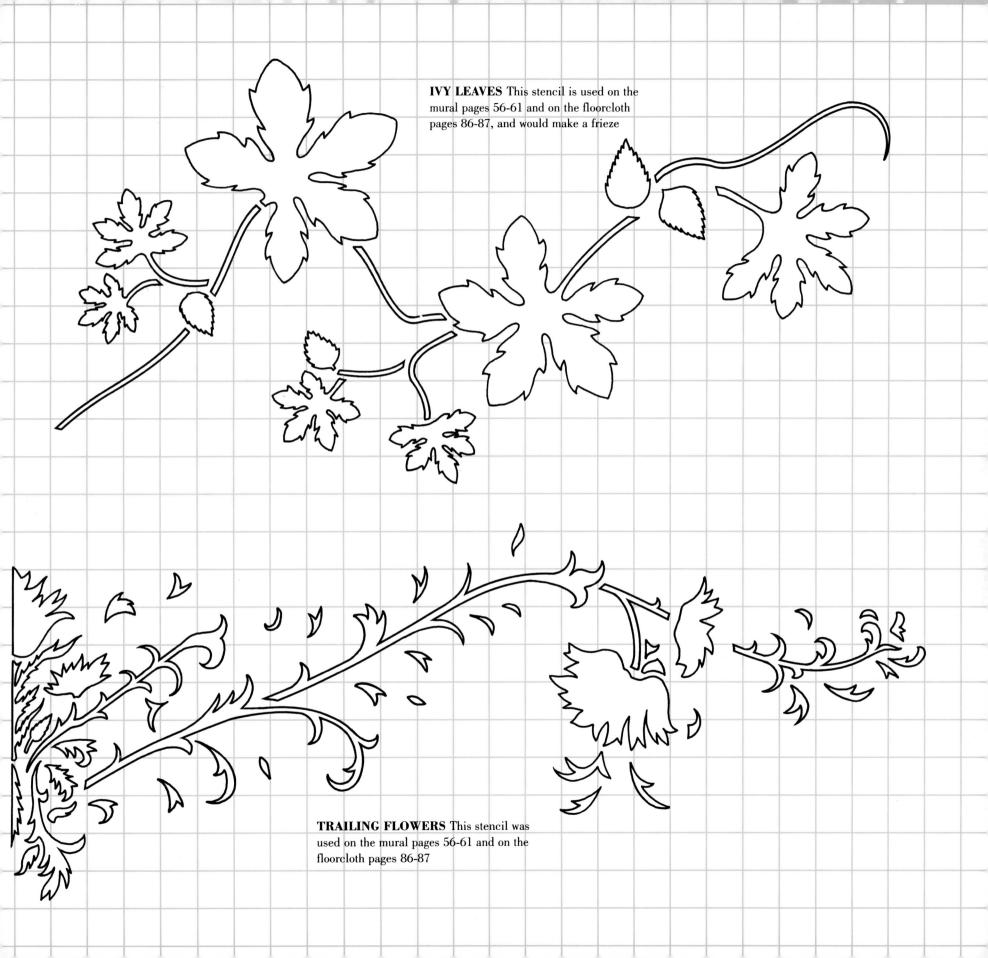

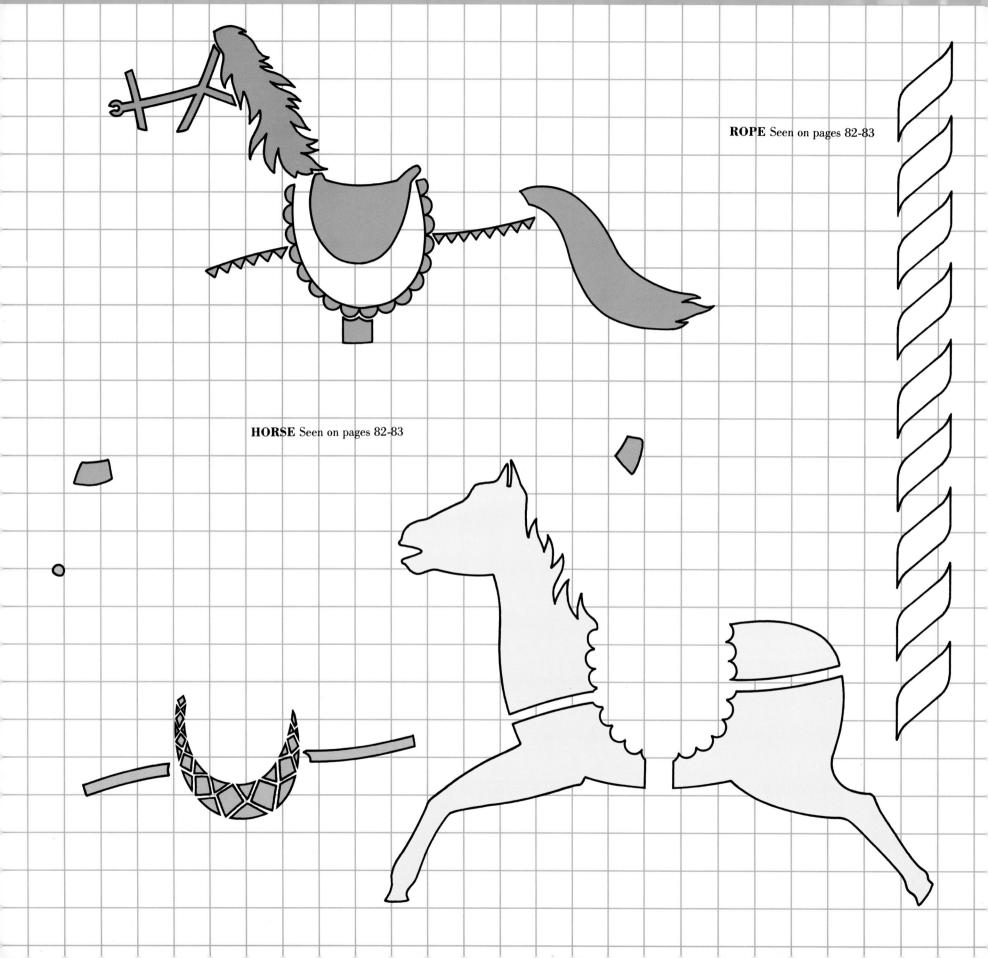

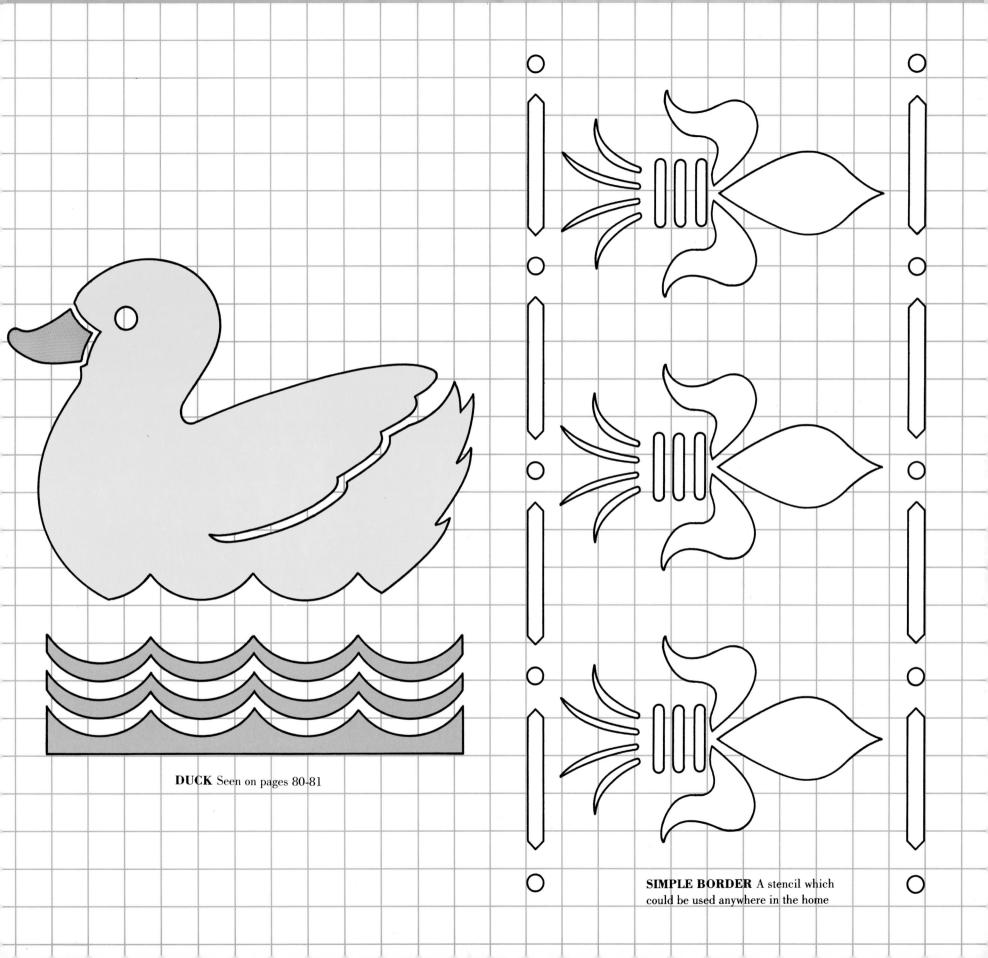

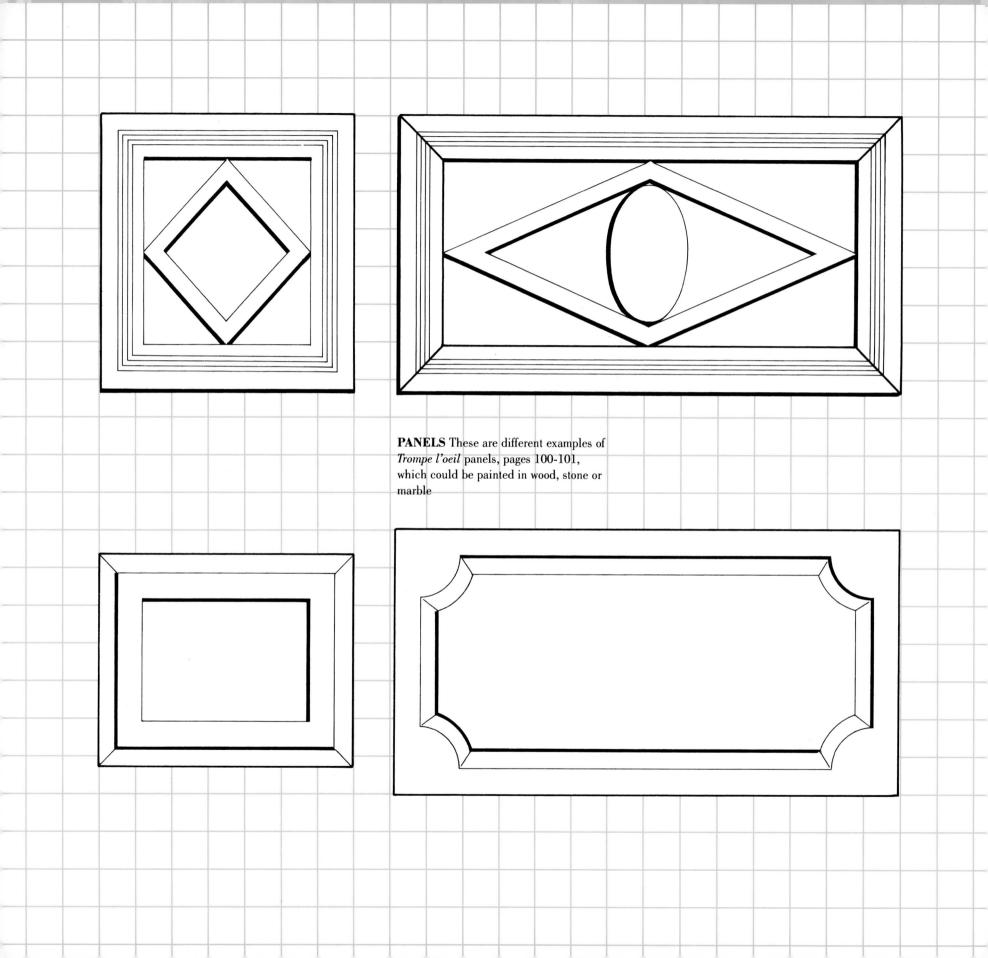

ACKNOWLEDGMENTS

Warner Fabrics Plc, Bradbourne Drive, Tilbrook MK7 8BE for the curtains on pages 92-93

Euro Studios; 'Mommy and Me' for the inspiration behind the carousel mural on pages 84-85

Tim Chitty and Simon Bacon at "Troesters" Guildford, UK for fabrics

John Olden at Woodcraft Furniture, Titchfield, Hampshire, UK

David Forrest at F.B. Design, Four Marks, Hampshire, UK

Mauro Peruccletti for the background effect on pages 20 and 99

"Chairs" from "Troesters" Guildford, UK pages 20 and 99

Mr and Mrs R Dennis

Mrs Alison Bouckley

Michael Alford for his help with the murals throughout the book

CONTRIBUTORS

Moira Japp
Malcome Hoile
Frank Anderson
Terry Tenger
Margaret Austin for all her help and advice throughout the making of this book

While every effort has been made to acknowledge all copyright holders, we apologise for any omissions made